Bi
~~Guide~~
to Japan

# JAPANESE CRAFTSMANSHIP

## SAWADA Mieko

photography by NAKANO Yoshito

SHOGAKUKAN

Bilingual Guide to Japan
# JAPANESE CRAFTSMANSHIP

SAWADA Mieko
photography by NAKANO Yoshito

Book and Cover design ©Kindaichi Design

Published by
SHOGAKUKAN
2-3-1 Hitotsubashi Chiyoda-Ku,
Tokyo 101-8001 JAPAN
https://www.shogakukan.co.jp
https://japanesebooks.jp/en/

KOGEI BILINGUAL GUIDE by
SAWADA Mieko, NAKANO Yoshito
©2018 SAWADA Mieko, NAKANO Yoshito,
MENUEZ Devon, SAITO Naomi / SHOGAKUKAN
Printed in Japan
ISBN 978-4-09-388657-4

# 工芸バイリンガルガイド

澤田美恵子　著

中野仁人　写真

小学館

# English renderings of Kogei Terms

This English and Japanese bilingual book introduces the basic knowledge and representative types of Kogei (Japanese craftsmanship).

All Japanese terms are rendered in Italicized Roman characters. The only diacritical to indicate long vowel sounds, and the hyphen ( - ), to separate two adjacent vowel sounds.

Production areas, names of shops, and artists are indicated at the end of the text in parentheses.

Since the conventions for rendering these terms into English differ depending on the facility, terms used elsewhere may not be consistent with those used in this book. Given that even Japanese names and pronunciations may differ depending on the sect or region, they cannot be generalized. Standard names are used in this book and are rendered so that they can be easily read by individuals who are not native speakers of Japanese.

## 本書の英文表記について

この本は、代表的な工芸品について紹介しています。日本語が母語ではない人のために、英語で訳してあります。

日本語はすべてローマ字読みにし、アルファベットで表記しています。母音が続いてしまう場合はハイフン (-) を使用しています。

産地および店名、作家名については文末に ( ) で示しました。

※これら外国語表記は、施設 (公共施設、地方自治体等) ごとに異なるルールで表記されているため、本書と一致しない場合があります。地方によって日本語でも呼び方が異なることがあり、一般化はできません。本書では標準的な呼称を掲載し、外国語を母語とする読者ができるだけ平易に発音できる表記としました。

# Table of Contents 目次

# Introduction

## What is Japanese Craftsmanship?

*Kogei* {ko:gay} expresses a unique Japanese perspective regarding art and craft. *Kogei* objects are created from principles different from those of objects designed for mass production and consumption. These objects are carefully made by hand, one by one, to be cared for, used for a long period of time, and repaired if broken. As these objects exist in our world longer than a person's life, they can be passed down from person to person over many generations. When used repeatedly over time, these objects improve in character and quality. Created with good, simple form, they emit a charming warmth. Composed of natural materials, *kogei* objects create no waste and will eventually return to the earth.

はじめに

●日本の工芸とは

「工芸」という言葉が指すものたちは、他の言語では適切な翻訳語を見出すことが難しい、日本の風土のなかで育まれた独自の美と用途を兼ね備えたものたちである。古からあるものなので、大量生産大量消費とは異なった原理で産みだされたものである。人間の手で1つ1つ丁寧に心を込めて作られ、大切に使われて、壊れたら修理され、長いあいだ人に寄り添って存在する。人から人へと世代を超えて使われ、時には人間よりも遥かに長くこの世に存在し続ける。長い年月のなかで使用と改良を重ねてきたので、良いもののフォルムはシンプルで無駄がなく、温かみがある。また自然の素材を使用しているので、その最後は土に還っていくのだ。

## The Artisan Spirit

In Japan, there are traditional skills in art and craft that have been handed down for generations. Many of the artisans that produce traditional arts and crafts within this book are able to communicate with the natural materials they both use and understand. The artisan who cherishes the spirituality between the earth and humans, and who truly listens to nature's voice, will be able to produce works without harming the environment. This aspiration, that aims for honest, careful craftsmanship, underlies the spirit of all those involved in making traditional crafts in Japan. In contemporary society, the harsh economic influence of globalization has created an era in which the ability to pass the culture of *kogei* on to the next generation is being threatened.

●職人のもの作り精神

こういった工芸品を作る技もまた何代にもわたって、人から人へと受け継がれてきたものである。この本で紹介する伝統的な工芸品を作る職人の多くが自然物である材料の声を聞き、理解して、それに適うようにものを作ってきた。日本の伝統的な工芸品を作ってきた職人は、自然の声を聞き、人と自然の関係を大切にして、地球を壊すことなくものを作っているのである。こういった嘘がない丁寧なもの作りの精神性は、「メイド イン ジャパン」の製品にも通底していたはずである。しかしながら、現代の迫りくるグローバリゼーションの経済の大波のなか、その職人魂は次の世代に受け継がれるのが困難となってきた。

**Beauty Through Cultivation**

In 2001, French anthropologist Claude Levi-Strauss said of Japan, "I cannot help but pray that Japanese people are able to succeed in maintaining a balance between innovation and the traditions of old. This is not only for Japanese people, but rather serves as an example worthy for all human beings."

I hope that by reading this book, those who feel that there is a connection between the craftsman and nature will find that the cultural and spiritual roots which flow through the production of handmade crafts continues to have meaning in the modern world. I will never cease in hoping that through this book, many will take up interest in Japanese *kogei*, and that many more will pause to consider the future of craftsmanship itself.

<div style="text-align: right">

Sawada Mieko, Ph.D.
Professor of Arts and Science, Kyoto Institute of Technology
Critic of Arts and Crafts / lovekogei.com

</div>

●生活に寄り添う日本工芸の魅力

　2001年フランスの民族学者クロード・レヴィ＝ストロースは、「日本の人々が過去の伝統と現代の革新の間の得がたい均衡をいつまでも保ち続けるよう願わずにはいられません。それは日本人自身のためだけに、ではありません。人類のすべてが、学ぶに値する一例をそこに見出すからです」と述べた。

　この本を読んで、ものを作る時の人間と自然の関係性に魅力を感じて下さった方は、工芸の「もの作り」に流れる根底の文化や精神性が現代の世界で意味をもつと思って下さったのではないだろうか。この本をきっかけに、日本の工芸に興味をもち、未来の「もの作り」について立ち止まって考えて下さる方が増えることを、心から望んでやまない。

<div style="text-align: right">

澤田美恵子
京都工芸繊維大学工芸科学研究科教授、博士（言語文化学）、工芸評論家

</div>

# Collectables

第一章

## 遊

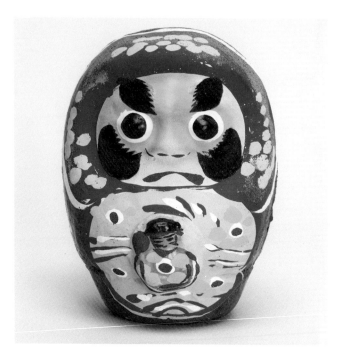

# *Daruma* (Good Luck Charm)

The *daruma* doll is made in the image of the Bodhidharma, the Buddhist priest who founded Zen Buddhism in India, in *zazen* (seated meditation). There are many different kinds of *daruma* good-luck mascots all over Japan. Photographed is a *hariko* (p.118) style *daruma*. Through the peace of mind and harmony that comes with *zazen*, one's feeling of the world also changes. "Fall seven times, get up eight." (Sendai, Miyagi prefecture)

だるま

　だるまは、禅宗の始祖とされるインドの仏僧・達磨大師の座禅姿を模したもの。日本全国に様々な開運の縁起物の「だるま」がある。写真は「張り子」(p.118)のだるま。座禅で呼吸や心を整えると世界観も変わる。七転び八起き。(宮城県仙台市)

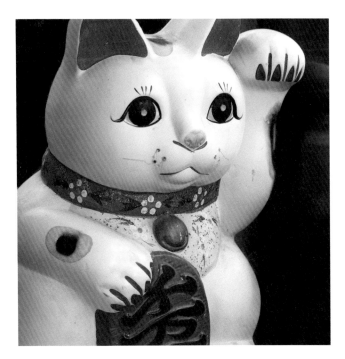

## *Maneki-neko* (Good Luck Talisman)

Since the Edo period (17th-19th centuries), the *maneki-neko* has become somewhat of a mascot for inviting both people and money. A cat that raises its right paw is said to bring cash and good luck, whereas the left-waving cat is thought to bring roaring business. It is said that different colors of the *maneki-neko* invite different things.

### 招き猫

　江戸時代（17〜19世紀）より、人や金を招く縁起物として親しまれている置物。右手を挙げている猫は、お金や幸運を招き、左手を挙げている猫は、千客万来とか。招き猫の色によっても招くものが異なるといわれる。

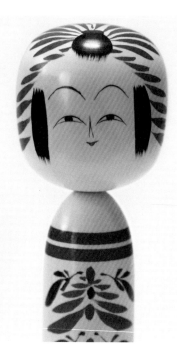

## *Kokeshi* (Limbless Wooden Doll)

*Kokeshi* first started being made as hot spring souvenirs around the close of the Edo period. These are charming dolls of simple form and face, made by rounding wood on the *rokuro* (p.118), much like a bowl. The word *kokeshi* comes from *koukeshi*, a talisman that prays for birth and children's happiness. (Miyagi prefecture)

こけし

　江戸時代の終わりごろに温泉土産として作られたのが始まりという。形も顔もシンプルで愛らしい人形だ。ろくろ (p.118) を使って、お椀と同様に木を丸く削って作られる。こけしの語源は「子授けし」、子どもの誕生や幸福を祈る縁起物だ。(宮城県)

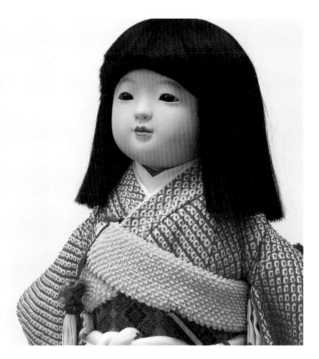

## *Ichimatsu-ningyo* (Ichimatsu Doll)

These dolls are made by applying several layers of *gofun* (p.118) onto a base of paulownia sawdust and gluten paste. The features are completed by a combination of engraving and applying paste, creating dolls which are each completely unique. These dolls are meant to be held and have their clothes changed. Legend has it, the name Ichimatsu comes from the *kabuki* actor Sanogawa Ichimatsu (1722-62), who was active during the latter half of the Edo period. (Tanakaya shop, Kyoto)

### 市松人形
　桐塑を基礎として胡粉 (p.118) を何回も塗り重ねて作られる。彫刻と塗りによって仕上げられ、世界で二つとない人形となる。着せ替えができる抱き人形だ。市松の名は、江戸時代中期に活躍した歌舞伎俳優、佐野川市松 (1722-62) に由来するという説もある。(京都市、田中彌)

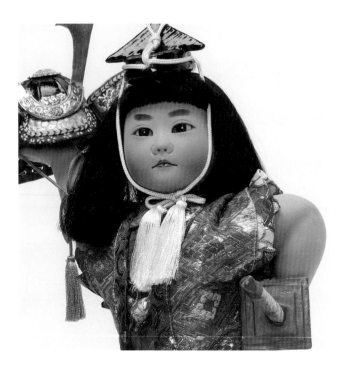

## *Gogatsu-ningyo* (Boys' Day Doll)

On *Tango no sekku* (p.119), May 5th, warrior dolls are decorated as military leaders and heroes from history, such as Kintoki and Shoki, to whom boys pray in hopes of growing up strong and healthy. Decorative armor and helmets are also called "Boys' Day dolls." The photograph shows an adorable Kintoki doll with chubby arms. (Kyoto)

五月人形

　5月5日の端午の節句 (p.119) には、男の子が強く健やかに育つように願って、金時や鐘馗など歴史上の武将や英雄をモデルとした武者人形が飾られる。鎧や兜飾り、甲冑なども、「五月人形」と呼ぶ。写真は腕がぷっくりした愛らしい金時の人形。（京都市）

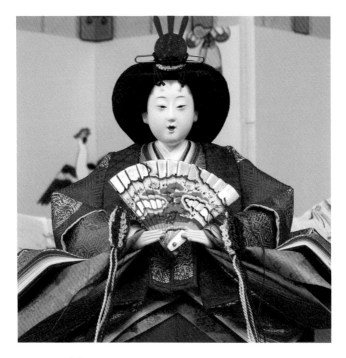

# *Hina-ningyo* (Girls' Day Dolls)

March 3rd is *Momono sekku* (p.119), and dolls are ceremoniously dressed in hopes that young girls will grow up well. Photographed is a *hina-ningyo* dressed in a *jyuni hitoe* (p.119) with a beautiful face. These dolls are made with a great deal of love and care going into each piece of cloth. *Hina-ningyo* is the generic name for emperor dolls and attendants that make up sets for display. (Ohashi Ippou shop, Kyoto)

## 雛人形

　3月3日の桃の節句 (p.119) に女の子の健やかな成長を願って飾る人形。写真は、十二単 (p.119) をまとった美しい顔の「お雛さま」。雛人形は裂地1枚1枚にも心が注がれ、愛情深く作られる。雛人形とは、対となる男雛のほか従者人形を含む総称。（京都市、大橋弌峰）

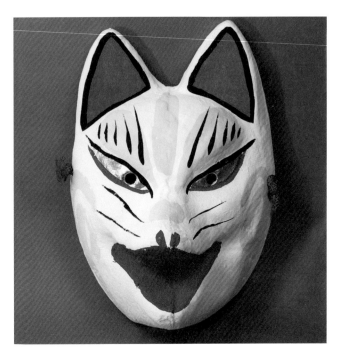

# *Kitsune-men* (Fox Mask)

*Kitsune-men* is a mask resembling the face of a fox, made from sawdust hardened with aged paste. The fox is considered a god in the Inari faith, which worships Inari Ogami, the god of agriculture. It is said that a white fox has supernatural powers. (Kyoto)

## 狐面

　　木の粉をしょうふ糊で固めて作られた白い狐の面。農耕神である稲荷大神を祀った稲荷信仰では、狐は神の使いとされる。特に白い狐は神通力をもつという。(京都市)

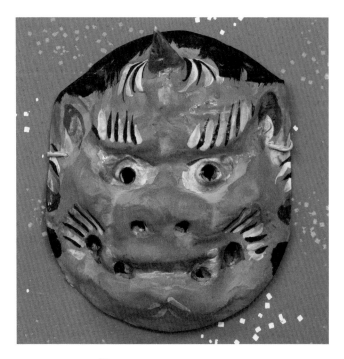

## *Sagamen* (Saga Mask)

*Sagamen* is a mask made in resemblence to masks used in *dai-nenbutsu kyogen* (silent mask plays) performed at Seiryo-ji temple (Ukyo ward, Kyoto) since ancient times. In the late Edo period, these masks are said to have been bestowed at shrines and temples in Saga as amulets to ward off harm and evil. Although there was a time this craft was no longer practiced, it has since been spectacularly revived. (Kyoto)

### 嵯峨面

　清涼寺（京都市右京区）で古く行なわれていた大念仏狂言（無言の仮面劇）の面を模して作られた、張り子の面。江戸末期には、厄除けや魔除けのお守りとして嵯峨の社寺で授与されたという。技が途絶えた時期もあるが見事に復興された。（京都市）

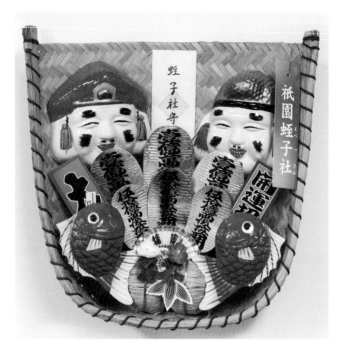

## *Ebisu-kazari* (God of Fishing Decoration)

Ebisu is one of the Seven Gods of Fortune who originates in Japan. The Grand Ebisu Festival, commonly known as "First Ebisu," is held at Ebisu shrine in the Gion district of Kyoto every year on January 10th. Auspicious symbols, such as bamboo leaves, used to pray for prosperity in one's business or home affairs, lucky carp, and the treasure ship of the Seven Gods of Fortune, are offered at the shrine. (Kyoto)

ゑびす飾り
　「ゑびす神」は七福神で唯一日本生まれの神様だ。毎年1月10日は京都・祇園にある恵美須神社の十日ゑびす大祭、通称「初ゑびす」。商売繁昌、家運隆昌を祈願した吉兆の笹や、縁起物の福鯛、宝船等が授与される。（京都市）

## *Oshie-hagoita* (Wooden Rackets Decorated With Raised Pictures)

Rackets made of paulownia wood are decorated with padded cloth pictures. These are used to play with shuttlecocks during the New Year and have also come to be used as decorative objects thought to bring luck by repelling harm and attracting good fortune. The *oshie* technique for producing these pictures involves covering thick paper with fine *habutae* (p.120) and stuffing with cotton padding. (Tokyo)

### 押絵羽子板

　桐でできた羽子板に押絵で装飾を施したもの。羽子板はお正月に羽根つきをして遊ぶ道具だが、厄をはね返し幸運を招く縁起物として、お飾りにもなったという。押絵は厚紙に羽二重（p.120）をかぶせ、中に綿を入れてふくらませてくるむ技。（東京都）

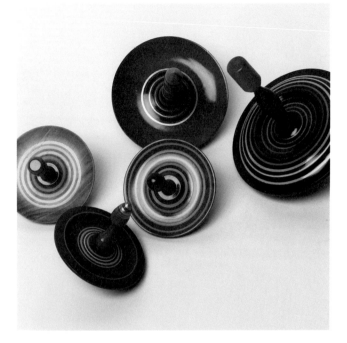

## *Koma* (Spinning Top)

A spinning top which, when standing upright, represents independence. The *iroiro hamagoma* tops pictured above are one of the crafts made on the lathe. Each is sharpened at a uniform thickness without inserting a weight, and has a unique way of spinning. The craftsmen of Nagahama are said to have inherited their skills from the fields of Higashi-omi, birthplace of the woodworking lathe. (Nagahama, Shiga prefecture)

### 独楽

　独楽は一本立ち、独立を意味する縁起物。写真のいろ色浜独楽は、ろくろ工芸品の1つ。錘を入れず均一の厚みで削ってあり、回り方も個性的。長浜の職人は、ろくろ木地師発祥の地・東近江市の技を継承したという。(滋賀県長浜市)

# *Yakkodako* (Kite)

*Yakkodako* is a kite decorated with the image of *yakko*, servants of the Edo period samurai household. The *yakko*'s hair is tied up at the back and he wears a beard. This character is painted on paper before attaching a framework of fine bamboo poles and a string so that the kite can be borne high into the sky on the wind. The site of these kites flying way up in the blue sky is thought to be invigorating. (Tokyo)

### 奴凧

　奴は江戸時代の武家の奴僕で、撥鬢、鎌髭の姿。奴を紙に描き、細い竹を骨にして糸をつけて風で空高くあげる奴凧。青い空に高くあがった凧は爽快だ。江戸時代に奴が武士を見下ろす姿はさぞ気持ち良かったろう。(東京都)

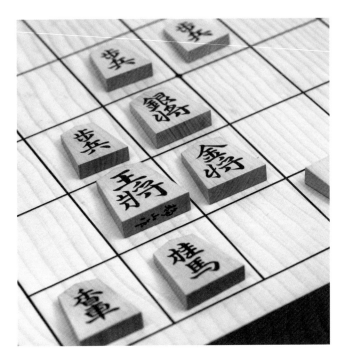

## *Shogi* (Japanese Chess)

It is said that *shogi* originated in India and was transmitted to Japan from Southeast Asia by way of southern China. The board shown in the photograph is made from Japanese nutmeg and the lines for the squares are drawn by a sword dipped in lacquer. The pieces have been carved from boxwood with characters written by Sekine Kinjiro (1868-1946), the father of modern *shogi*. (Oishi Tengudo shop, Kyoto)

### 将棋

　インドにおこり、東南アジアから中国南部経由で伝来したという。写真の盤は本榧、升目は日本刀に漆をつけ、線を引いている。駒は近代将棋の父、関根金次郎（1868〜1946）の書をもとに、本柘植を彫り、漆で埋め、盛りあげたもの。（京都市、大石天狗堂）

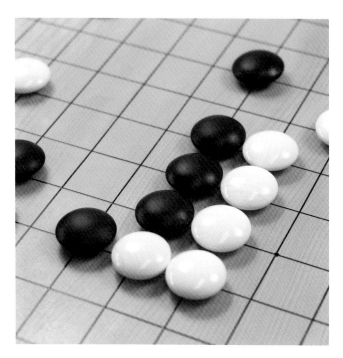

## *Go* (Japanese Boardgame)

*Go* is a game in which two players take turns placing black and white stones on a board with 361 grids. The match is adorned by exquisite implements, such as the boards pictured above, made of rare Japanese nutmeg wood with stones made of genuine shell, and *kogei* (containers for the stones) made of mulberry wood. (Oishi Tengudo shop, Kyoto)

碁
　縦横19本の線により仕切られた361の目がある盤上に、2人が交互に1つずつ黒と白の碁石を並べていく遊戯。希少な本榧の碁盤、本蛤の碁石、本桑の碁笥（碁石を入れる器）など、優美な道具が勝負を彩る。（京都市、大石天狗堂）

## *Pochi-bukuro* (Petit Envelope)

This small decorative envelope, a miniature version of the envelopes used for congratulatory gifts, is used to hand cash tips and money directly to the recipient. The term *pochi* is part of the Kyoto dialect, meaning something small or cute. In the *geisha* quarter, the givers used all their ingenuity to express a playful spirit, and so the designs were extremely elegant. Their sentiments were conveyed in a stylish manner. (Kyoto)

### ぽち袋

　ぽち袋は、心付けの金銭や金品を入れて手渡す、小さな祝儀袋である。「ぽち」は上方ことばで小さいもの、かわいいものを意味した。花街などで用いられたものは、贈り手が趣向をこらして遊び心を表現したため、意匠も優れ艶やかだ。粋に、心が伝えられる。（京都市）

## *Karakami* (Tang Style Paper)

Beautifully patterned paper brought to Japan from China during the Tang dynasty was called *karakami*. In the Heian period (8th-12th centuries), paper imitating this style was made in Kyoto by covering a wooden printing block with mica, working it into paint, and printing a design. This paper was called *kyo-karakami*, and was habitually used for writing letters and poems. Pictured is a painted *hagaki* (postcard) with cherry blossom pattern. (Kamisoe shop, Kyoto)

### 唐紙

中国・唐から日本に渡来した美しい模様の紙を唐紙と呼んだ。平安時代（8～12世紀）、京でその紙を真似て板木に雲母をのせ、模様を刷った紙を京からかみという。手紙や詩歌を書くための料紙として愛用された。写真は、桜模様の絵はがき。（京都市、かみ添）

# *Shishu-bari* (Embroidery Needle)

*Kimono* from Kyoto have long been held in high regard, thus well-made tools have also been produced in support of this trade. Since the Edo period, *shishu-bari* have become known nationwide as high-quality souvenirs that do not take up space in one's luggage. The photograph shows a handmade *oisho* (p.120) needle used for large costumes and traditional Japanese embroidery. It is enjoyable to learn the different names given to needles according to their thickness. (Sanjo-Honke Misuyabari shop, Kyoto)

## 刺繍針

　京の着物は昔から名高く、それに伴う道具も良いものが作られた。針は荷物にならない質の良い京の土産品として、江戸時代より全国に名を轟かせたという。写真は手作りの日本刺繍の針の大衣裳(p.120)。針の太さによって名前も異なり、楽しめる。(京都市、三條本家みすや針)

## *Kiseru* (Pipe)

This pipe consists of a bowl, neck, stem, and mouthpiece. It is stuffed with chopped tobacco, lit, and smoked. The stem is a bamboo tube which absorbs tar as the smoke passes through it. When the stem becomes blocked, it is exchanged for a new one. Those with a taste for stylish smoking do not need much tobacco. Today, there are very few craftsmen left keeping this elegant culture alive. (Tanigawa Seijiro Shoten shop, Kyoto)

きせる

　きせるは、火皿、雁首、羅宇、吸口からなり、刻み煙草をつめ、火をつけて吸う。羅宇は竹管で、煙が通る時にヤニを吸収し、溜まると交換されるもの。粋に煙草を嗜めば量はいらない。数少ないきせる職人が、粋の文化を守る。（京都市、谷川清次郎商店）

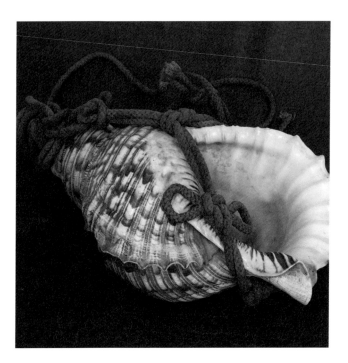

## *Horagai* (Conch Shell)

The photograph shows a conch shell with a golden mouthpiece and braided cord with decorative knots, used by *yamabushi* (mountain ascetics). *Horagai* are blown when performing devotional practices or walking in the mountains, and are believed to transmit teachings to many people. In the Warring States period (15th-16th centuries), they were used to signal the joining of battle and to raise fighting spirits.

### 法螺貝

　写真は山伏用の法螺貝で口金具とくみひも結緒が付いたもの。山伏が勤行の時や山を歩く時に吹く法具で、正しい教えを多くの人に伝えるという意がある。戦国時代（15〜16世紀）には合戦の合図や戦意高揚に用いられた。

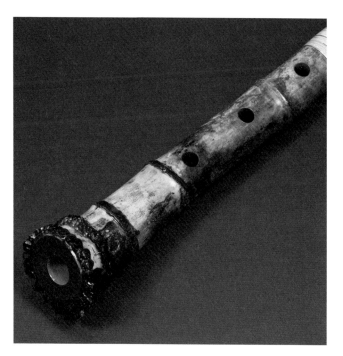

## *Shakuhachi* (Bamboo Flute)

In winter, when bamboo growth is at its most sluggish, bamboo that is to be used for a *shakuhachi* is chosen and harvested. It is then seared over a fire to give it a well-balanced shape. Although the *shakuhachi* played by wandering priests are made only from the bamboo in its natural state, the interior of the modern-day *shakuhachi* is coated with clay so that it can be played more efficiently. Today, the *shakuhachi* can even be played in an orchestral performance. (Kitahara Seikado, Kyoto)

尺八
　真竹の活動が鈍る冬、尺八とする竹を選び採掘する。そして火で炙り均整のとれた形にする。虚無僧の尺八は竹をそのまま使うが、現代の尺八は音が効率よく鳴るように内径に下地を塗る。こうして尺八は、今やオーケストラとも演奏できる楽器となった。(京都市、北原精華堂)

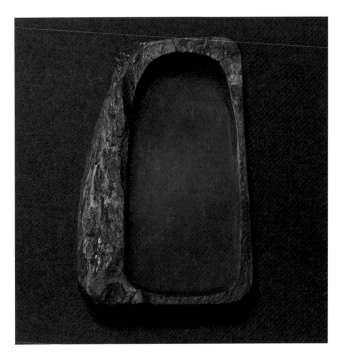

## *Suzuri* (Inkstone)

*Suzuri* are tools made of stone or tile and used to grind *sumi* (ink sticks) with water. The photograph shows a handmade *suzuri* in the shape of a natural stone. The artisan needs skill to select and painstakingly split and polish each stone. Grinding *sumi* on a *suzuri* that has been made with loving care is thought to purify the soul. (Ishinomaki, Miyagi prefecture)

硯

　硯は墨を水でするために使う道具で、石や瓦などで作ったもの。写真は自然石の形を生かした手作りの硯。石を見分け、丹念に削り磨き上げる職人技が必要だ。心を込めて作られた硯で墨をすると、心も洗われる。（宮城県石巻市）

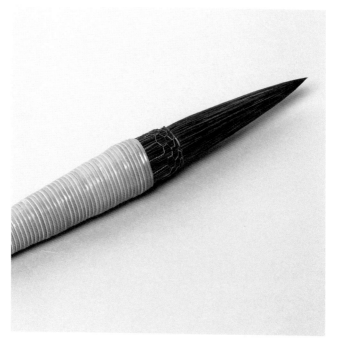

# *Fude* (Brush)

A *fude* is a tool used for writing and painting with *sumi* or other mediums. Various *fude* are made throughout Japan. Photographed above is an *unpei-fude* from Shiga prefecture that has been made by rolling *shinmo* (kneaded hairs) with high-quality Japanese paper, tightening them, adding an outer layer of bristles, and binding them together with linen thread. These brushes are firm and produce powerful lines. (Hankeido shop, Shiga prefecture)

筆

　筆は墨や絵の具を含ませて、文字や絵を描くための道具。様々な産地で種類も多く作られている。写真は滋賀県の雲平筆といい、芯毛（練りまぜた毛）を上質の和紙で巻き固め、上毛をかけ、麻糸で締めるという製法の巻筆。腰が強く、力強い筆線がでる。（滋賀県、攀桂堂）

# Apparel

第二章

# 衣

## *Nishijin-ori* (Nishijin Silk Brocade)

Since the Heian period, the silk weaving business has flourished in Kyoto. The origin of the name *nishijin* originates just after the Onin War (1467-77), when production resumed at the site of the western army's headquarters. *Nishijin-ori*, a textile made using dyed threads to weave patterns and designs, is made by expert craftsmen who carry out elaborate work during every stage of the complex process. (Kyoto)

### 西陣織

　平安時代より京は絹織物業が盛んであった。応仁の乱 (1467-77) の後、西軍の本陣があった地で生産を再開したことが、西陣織の名の由来。染色した糸を使って、文様・柄を織り出す先染の紋織物である西陣織は、多くの工程の1つ1つで熟練の匠が丹念な仕事をする。(京都市)

# *Nihon-shishu* (Japanese Embroidery)

Embroidery is a decorative technique which employs one needle and threads of many colors to sew designs onto fabric or other materials. When embroidery is added to dyeing and weaving, the fabric becomes three-dimensional and flamboyant. The Japanese character for picture, 絵 (*eh*), is a combination of the kanji for thread 糸 (*ito*) and "to meet" 会 (*au*), and thus comes to mean "a meeting of threads." Photographed is an example of *kyonui* (p.121). (Kyoto)

**日本刺繍**

　刺繍は1本の針と多色の糸を使って布地などに模様を縫い表す装飾技法。染めと織りに刺繍が加わり立体感と華やかさが増す。「絵」という字は糸が会うと書く。刺繍は布に思いのままに絵を描ける古代からの技である。写真は京繍 (p.121)。(京都市)

## *Yuzen* (Resist-dyeing)

A technique for dyeing designs onto cloth that was originally defined as a type of resist-dyeing in which designs were hand-drawn with rice-based starch. Currently, the majority of items are either dyed using a stencil or printed with *yuzen*-type motifs. Its name is derived from Miyazaki Yuzensai (dates unknown), a painter of folding fans in the Edo period. The motifs draw on this illustrator's tradition. Kyoto and the old Kaga province (Ishikawa prefecture) are well-known for this technique. (Kyoto)

### 友禅
　布に模様を染める技法の1つ。本来でんぷん質（米製）の防染剤を用いる手描きの染色を指したが、今は型染めや友禅を模した模様を染めたものも多い。友禅という名は、江戸時代の扇絵師、宮崎友禅斎（生没年不明）にちなむ。文様に絵師の伝統を汲む。京都や加賀（石川県）などが有名。（京都市）

# *Shibori* (Tie-dyeing)

*Shibori* is a detailed method of dyeing in which each spot to be left undyed is pinched and bound three or four times with silk thread. The design is composed of these spots, which, as they are the result of minute handiwork, do not change over time. The photograph shows a fine-quality *hitta-shibori obi-age* sash of tie-dyed silk. (Kyoto)

絞り

　絞りとは、絞り目を1粒ずつ摘みながら、絹糸を3回から4回巻き、絞り目で模様を構成していく精緻な技法。細かな手作業でできた絞り目は時間を経ても変わらない。写真は絹に絞りを施した高級な疋田絞りの帯揚げ。(京都市)

# *Chirimen* (Silk Crepe Textile)

A cloth made of plainly woven silk, whose distinctive grain and texture is called *chirimen*. The photograph shows *tango-chirimen*. Kinuya Saheiji (p.121) served as an apprentice in a weaving shop in Kyoto's Nishijin district during the Edo period. It is said that he brought the craft back to Kyotango and laid the foundations of the technology for the yarn twisting and weaving machine that creates this texture. Nagahama (Shiga prefecture) and Joetsu (Niigata prefecture) are also known for *chirimen*.

### 縮緬

　絹を平織りにした布。写真は丹後縮緬。独特のシボ（凹凸）と絹の風合いは、江戸時代に絹屋佐平治（p.121）が京都西陣の機屋へ奉公し、技を学び丹後（京丹後市）へ持ち帰って、糸撚り機や織りの技術の礎をつくったことで生まれた。長浜（滋賀県）や上越（新潟県）の縮緬も有名。

# *Komon* (Fine Pattern Motif)

A dyeing technique that originated with the pattern of samurai clothing that was perfected by the 17th century. In the Edo period, a linen tunic and pants dyed using this method became formal attire for samurai, and over time, it also became popular among the common people. A *kyokomon* pattern is pictured above. Although the technique had an influential relationship with *yuzen* in Kyoto, it was able to develop in its own, unique way. (Kyoto)

## 小紋

　武士の裃の文様に始まり17世紀ごろまでにほぼ完成された染めの技法。江戸時代に小紋を染めた麻裃が武士の正装となり、やがて庶民の間でも流行する。写真は京小紋。京都では友禅と影響し合いながら、独自に発展した。(京都市)

## *Aizome* (Indigo Dyeing)

*Aizome* is a fabric dyed using natural knotweed, which produces indigo dye. It is said that clothes dyed with indigo have insect-resistant, insulating, and anti-bacterial properties. *Aizome* became popular throughout the masses in the Edo period, and was adopted for use with various crafts and worker's clothing. The photograph shows scraps from the outer *obi* belts dyed with medium-sized patterns. (Kyoto)

### 藍染

　天然の蓼藍を原料として染めた布。藍染の衣服は防虫、保温、抗菌などの効果があるといわれ、江戸時代には庶民にまで普及し、作業着をはじめ様々なものに採用された。写真は中型染の帯側裂。（京都市）

# *Jofu* (Woven Hemp Textile)

*Jofu* is a thin hemp fabric of fine quality. Rumor has it, *jofu* received its name from the term *jono* (payment to the government) because it was once paid as a tax. On a loom, threads in the vertical position are referred to as "warp," and the horizontal threads as "weft." In the *omi-jofu* technique, the warp is dyed with the *kushioshi nassen* technique (p.121), and the weft, *katagami nassen* (p.122). The splashed pattern created by different methods is a gentle one. (Higashi-omi, Shiga prefecture)

## 上布

　品質の良い薄地の麻織物。上納されていたことから上布という、との説もある。近江上布は、経糸を櫛押捺染 (p.121)、緯糸を型紙捺染 (p.122) で染める。異なる技法で染められた経糸と緯糸が織りなす絣模様は和やか。(滋賀県東近江市)

## *Chijimi-ori* (Cotton Crepe Textile)

This fabric is woven using strong, twisted yarn for the weft and wrung to create fine creases across the entire surface. The varieties include both linen and cotton. Although a *kimono* is pictured, a *jinbei* (casual jacket and pants) made of such milled cloth is good for relaxing in the summer. (Kyoto)

### 縮織

　緯糸にやや強い撚糸を用いて織り、練ってしわ寄せして布面全体に細かいしわを生じさせた織物。麻、木綿などの種類がある。写真は着物だが、縮織の甚平など、夏にはさらっとくつろげる。(京都市)

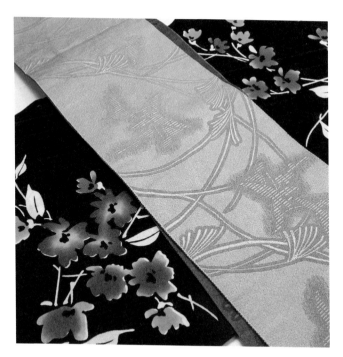

# *Yukata* (Casual Summer Kimono)

In the Edo period, the unlined *hitoe* (p.122) worn before and after a bath was called *yukata-bira*. The term has since been abbreviated to *yukata*. In the past, the majority of *yukata* were dyed with indigo in order to repel bugs when worn after taking a bath at dusk. Pictured in the center of the photograph is a yellow *hanhaba-obi* (half-width belt) with a pampas grass design. (Kyoto)

浴衣

　江戸時代には入浴の時や入浴後に着る単衣(p.122)を「湯帷子」といった。現在では、それを略して浴衣と呼ぶようになったという。昔は浴衣は藍で染めたものが多く、夕方、湯上がりに着ても藍のおかげで虫よけの効果もあった。写真中央の黄色い布はススキ柄の半幅帯。(京都市)

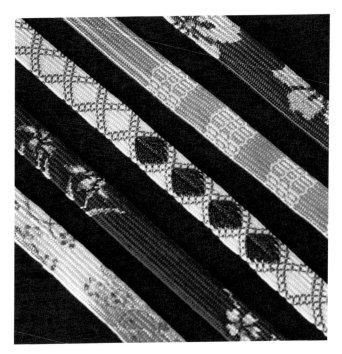

# *Kumihimo* (Braided Cord)

*Kumihimo* have been made in Kyoto since the Heian period. These cords evolved from a component of armor in the Kamakura period (12th-14th centuries) to having a decorative use as tea utensils in the Azuchi-Momoyama period (16th century), and finally, as an *obijime* cord for tying *kimono obi* belt in the Edo. Handmade *obijime* cords hold the *obi* belts tightly and comfortably in place. (Kyoto)

くみひも

　京でくみひもが作られるようになったのは平安時代から。鎌倉時代（12～14世紀）には武具の一部、安土桃山時代（16世紀）には茶道具の飾り紐、江戸期には帯締めを開発した。手組みのくみひもは丸台、高台、角台などの道具を使い手で組む。手仕事の帯締めは、しっかり帯を支え心地よい。（京都市）

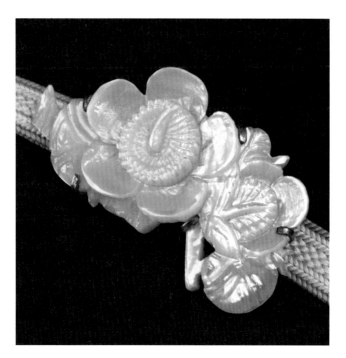

## *Obidome* (*Obijime* Cord Ornament)

An ornament threaded onto the *obijime* cord that is used to tie a woman's *kimono obi* belt in place. The photograph shows an *obidome* in the form of a plum blossom, intricately carved from a shell. It brings to mind the vision of plum blossoms perfuming the air despite the bitter cold, as well as a beautiful woman. Plum blossoms are an auspicious motif favored in both China and Japan.

帯留

　女物の帯をおさえ結ぶ紐や、それに通し装飾とする細工物。写真は貝に精緻な彫りを施した梅の帯留。まだ寒さが厳しいなか、香り高く咲く梅の花に、凛と美しい女性の姿を想う。梅は中国でも日本でも好まれる縁起の良い文様。

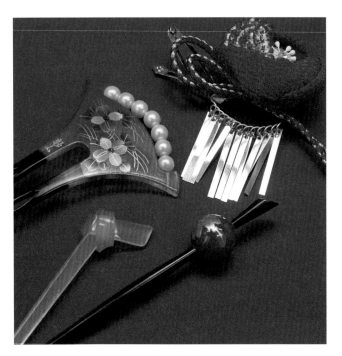

# *Kami-kazari* (Hair Ornaments)

Ornaments used for traditional Japanese hairstyles include combs, hairpins decorated with balls, and hairpins with elaborate hanging decorations. Fastening a favorite hair ornament into beautifully arranged hair is said to make one's heart sing. At the Comb Festival in Kyoto's Yasui Konpira shrine, gratitude is expressed to old or damaged *kami-kazari*, and a memorial service is held in their honor. (Kyoto)

## 髪飾り

日本髪の髪飾りは、櫛、玉かんざし、ちりかんざしなど。綺麗に結われた髪にお気に入りの髪飾りを付けると心もおどる。京都・東山の安井金比羅宮の櫛まつりでは、古くなったり傷んだりした櫛やかんざしに感謝して、供養する。(京都市)

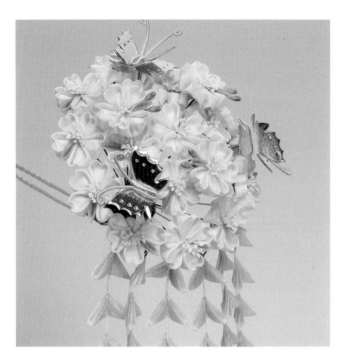

# *Hana-kanzashi* (Flower Hairpin)

Once the Miyako Odori dance festival begins, spring has arrived in earnest in Kyoto. An *okiuta* dance is performed by apprentice *geisha* wearing hairpins decorated with cherry blossoms and other flowers, along with cries of *Miyako odori wa yoi yasa*! (let's start the cherry dance!) Ornamental hairpins decorated with flowers are a uniquely Kyoto craft. These pins and *kimono* add color to each season. The artisan's skill in dyeing each petal one-by-one is resplendent. (Kintakedo shop, Kyoto)

花かんざし

「都をどり」が始まると京都の春も本番だ。「都をどりはヨーイヤサー」のかけ声とともに桜などの花かんざしをした舞妓さんが舞う「置歌」。花かんざしは京都ならではの工芸品。着物とともに季節を彩る。花びら1枚1枚を染める職人技が輝く。(京都市、金竹堂)

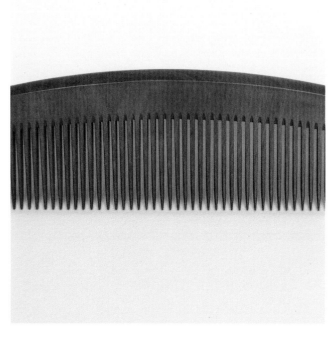

# *Tsugegushi* (Boxwood Comb)

Boxwood is a fine-grained wood with lustrous oil. Because it does not damage the hair, *tsugegushi* have been esteemed objects since the age of the gods. They are also characterized by the way they develop a more profound character the longer they are used. The teeth of the comb are hand cut with a saw by a skilled craftsman, one at a time. (Kyoto)

### つげ櫛

　つげの材は、きめが細かく、木からでる天然の油分によって艶がある。髪を傷めることがなく、つげ櫛は神世の時代から尊ばれてきた。使うほどに味がでてくるのも特徴だ。櫛の歯は熟練した職人の手で1本ずつ、のこぎりで挽かれている。(京都市)

## *Kyobeni* (Kyoto Lip Color)

A precious red lip color made from tiny quantities of crimson coloring extracted from many thousands of safflowers is called *kyobeni* because it is a high-quality lip color that was refined in Kyoto. The safflower extract is painted in many layers either on the inside of a lidded, white porcelain container or both halves of a clam shell. *Kyobeni* is said to be a gift suitable for a woman who longs to be beautiful. (Kyoto)

### 京紅
　何千もの紅花からほんの少しの紅しかできない貴重な赤の口紅。京で上質なものが精製されたため京紅と呼ぶ。紅液を蓋付きの白色磁器の碗や蛤の両面に何度も塗り重ねたもので、器ごと工芸品だ。京紅は、美しくありたいと願う女性への贈り物にふさわしい。(京都市)

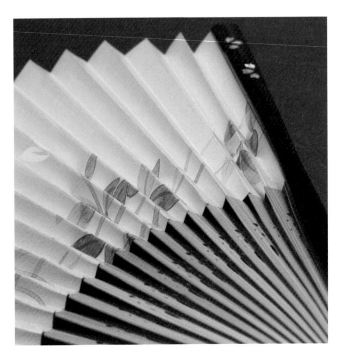

## *Sensu* (Folding Fan)

*Sensu* were first produced in the ancient capital of Kyoto at the start of the Heian period. Japanese people are particularly skillful at producing compact items. The basic form of the folding fan is the Japanese cypress formal fan, which features narrow boards of Japanese cypress. *Sensu* have long enjoyed popularity as the stars of the export industry; although they originate in Japan, they are keeping people cool all over the world. (Kyoto)

### 扇子

　扇子は平安時代の初めに京の都ではじめて作られた。コンパクトになるものを作るのは日本人の得意技だ。檜の薄板を綴じた檜扇が扇子の原型。輸出産業の花形として古くから盛んだった。日本発の扇子が世界中の人に風を送っている。（京都市）

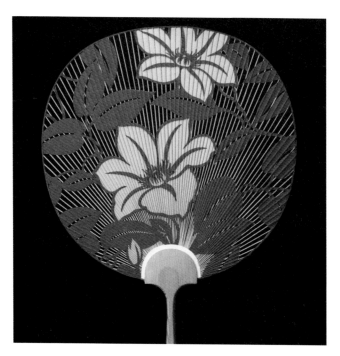

# *Uchiwa* (Round Fan)

*Uchiwa* are said to have been used both by the Imperial Court and in Shinto and Buddhist ceremonies since the Nara period (8th century). The *kyo-uchiwa* in the photograph is distinguished by its "inserted design" structure, for which the surface of the fan and the design have been made separately, and the design, inserted later. Waving a fan not only allows you to enjoy a cool breeze, but the sight of it refreshes your spirit. (Kyoto)

うちわ

　うちわは奈良時代（8世紀）、宮中や神仏の儀式に用いられていたという。写真の京うちわは、うちわ面と柄を別に作り、後に柄を差し込む「差し柄」の構造が特徴だ。あおいで涼をとるだけでなく、見て心を涼やかにしてくれる。（京都市）

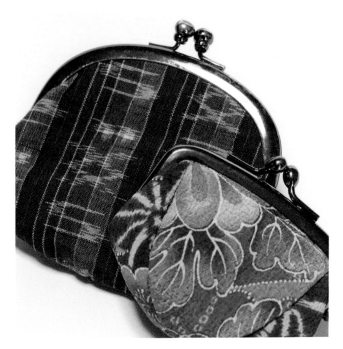

# *Gamaguchi* (Metal-clasped Pouch)

A receptacle with a metal clasp, often called "frog's mouth" because of its resemblance in shape when opened. Recently, these handbags have not only started being made as wallets, but also with additional tiny pockets and metal clasps on the reverse side. Classes on making *gamaguchi* have also become popular. *Gamaguchi* skillfully made by Kyoto artisans are highly valued. (Kyoto)

がま口
　開いた形がガマの口に似ていることから、名がついた口金のついた入れもの。最近は財布だけでなく、小物入れやバッグにも口金が使われている。手作り教室も盛んだ。京都の熟練の職人ものは評判が高い。(京都市)

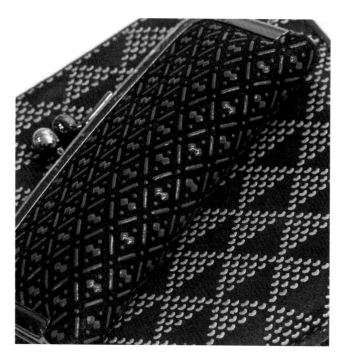

## *Inkan-ire/Saifu* (Seal Case/Wallet)

A case or wallet of tanned deer or sheep hyde and fine embossing on the surface, specifically for carrying one's personal seal. One of the most charming aspects of these cases are their *urushi* (lacquer) motifs. *Urushi* is applied evenly with a stencil to produce a three-dimensional effect. This leather is gentle on human skin and fits more and more comfortably into the hand the longer it is used. (Kofu, Yamanashi prefecture)

印鑑入れ・財布
　鹿や羊のなめし革を使い、細かなシボを特徴とする印伝（革工芸）の印鑑入れと財布。印伝の魅力の1つは漆の文様だ。型染めで立体的に均等な漆塗りは熟練を要す。人肌に優しく、使い込むほど手になじむ。（山梨県甲府市）

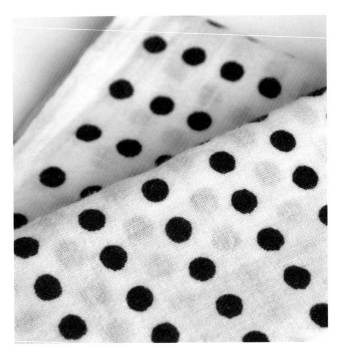

# *Tenugui* (Hand Towel)

*Tenugui* are designed to wipe the hands, face, or body, and are made of pieces of cotton around 3 *shaku* (approximately 90cm) long. The photograph shows a *tenugui* with a polka-dot pattern. These cloths can be used as a headband, bandana, or handkerchief, as well as to wrap lunchboxes and plastic bottles. If you take a *tenugui* with you to a festival or when you go on an outing, it is sure to prove convenient in some way. (Kyoto)

手ぬぐい

　手や顔・体をぬぐうための布で、3尺（約90㎝）ぐらいの長さの木綿布だ。写真は、豆絞り（水玉柄）の手ぬぐい。鉢巻、バンダナ、ハンカチの代わり、お弁当やペットボトルも包める。祭りや行楽などに持っていくと何かと便利。（京都市）

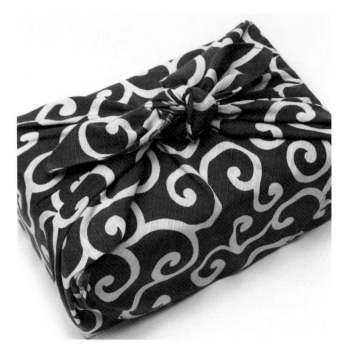

## *Furoshiki* (Large Square-shaped Cloth)

*Furoshiki* are very versatile items used for easy transportation of goods. The foliage scrollwork motif in the photograph has its origins in Egypt, Mesopotamia, and Greece. In Japan, the design came to be used in combination with other flowers and plants such as grapevines or peonies. *Furoshiki* with foliage scrollwork motifs were popular in the later Edo period because they were seen as auspicious. (Kyoto)

### 風呂敷

　　風呂敷は物を包むのに用いる方形の布。写真の唐草文様はエジプト、メソポタミア、ギリシャなどに起源をもつ。日本では、葡萄や牡丹など他の草花とも組み合わせて用いられるようになった。唐草の風呂敷は、江戸時代後半に縁起が良いことから人気をえた。(京都市)

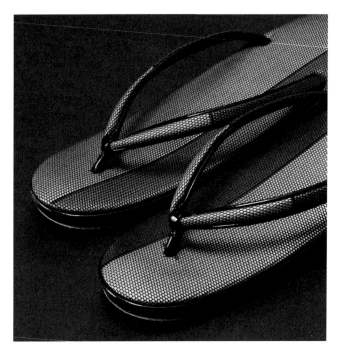

## *Zori* (Japanese Sandals)

Footwear of woven straw, bamboo, *igusa* (p.122), and other materials. The *zori* in the photograph are made with the *shikoro* technique, which was originally a method used for weaving the side plates and jaw covering of a warrior's helmet. These were woven using thin strips of leather and vertical threads. (Kyoto)

草履

　藁、竹皮、い草（p.122）などを編んで、鼻緒をすげた履物。写真はしころ織の草履。しころは兜の鉢の左右から後方に垂れて顎を覆うもので、しころ織も元は鎧の織り方。横に革を細かく切ったものを縦に糸を使って織られる。（京都市）

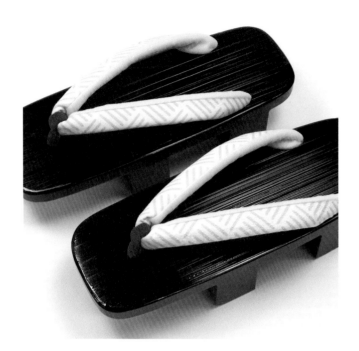

## *Geta* (Japanese Clogs)

Footwear that has two ridges as a wooden base and three holes through which a thong is tied. The photograph shows *geta* of beautiful straight-grain paulownia wood. The wood is given repeated coatings of black lacquer, whose brushstrokes are made to resemble the straight grain of the tree.

下駄

　2枚の歯のある台木に3つの穴をあけ、鼻緒をすげた履物。写真は柾目が美しい桐の下駄。柾目とは木の幹の中心を通って縦断した面に見られるまっすぐな木目のこと。黒の漆を何度も塗り重ね、刷毛目を模様に生かしている。

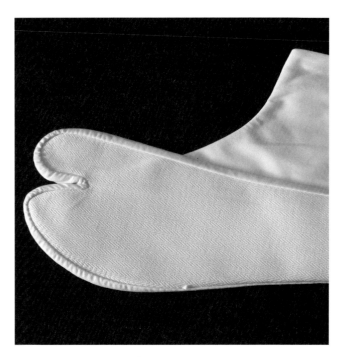

## *Tabi* (Split-toe Socks)

Socks worn with traditional Japanese clothing. These separate the big toe from the others in order to be worn with *geta* and *zori*, and are fastened with small, claw-shaped, metal hooks. Leather *tabi* were made at the end of the Kamakura period; those made of cotton became widespread in the Edo. In the time of Sen no Rikyu (1522-91), it is said that the tea ceremony was performed in bare feet, with leather *tabi* permitted only in the cold season. (Kyoto)

### 足袋

　和装の時に身につける袋状の履物。草履や下駄を履くため、親指と他の指が分かれ、合わせ目を爪型の小鉤という金具で留める。鎌倉時代末に革製ができ、江戸時代に木綿製が広まった。千利休（1522〜91）の時代は茶の湯でも基本的に裸足で、寒い時だけ革足袋が許されたという。（京都市）

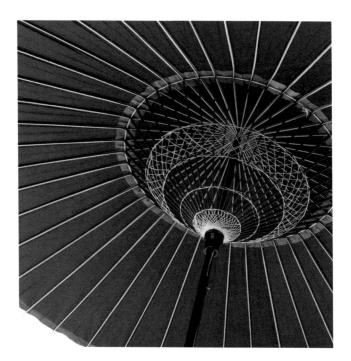

# *Wagasa* (Japanese Umbrella)

Umbrellas are said to have been brought to Japan from China by the Heian period, but umbrellas which could be closed date from the Azuchi-Momoyama period. Perhaps because it took nearly one hundred years to develop an umbrella which was capable of opening and closing, the mechanism performing this function on the Japanese umbrella is particularly streamlined and beautiful. On a rainy day, I find myself fascinated by the sight of a person wearing a *kimono* and holding a *wagasa*. (Hiyoshiya shop, Kyoto)

和傘

　傘は平安時代までには中国より伝来したといわれるが、閉じることが可能となったのは安土桃山時代以降。傘が開閉できるまでに長い年月を必要としたためか、和傘の開閉部の構造は無駄がなく美しい。雨の日、着物姿で和傘をさす人に思わず見とれる。(京都市、日吉屋)

Chapter 3

# Tableware

第三章

食

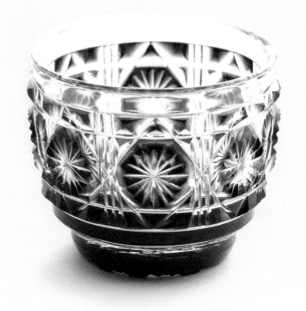

## *Choko* (Sake Cup)

It is said that the Japananese pronunciation of the Chinese term for "round bronze alcohol jar" gradually shifted to *choko*. The characters used to write the word were assigned on a phonetic basis. The word most often denotes a small pottery cup, with around a 5cm diameter, for drinking *sake*. The cup in the photograph is made of cut glass called *satsuma-kiriko*. *Edo-kiriko* is also popular. (Kagosima)

猪口

　酒器を意味する中国語「鍾」の発音チョクが転じ「ちょこ」となったといわれる。猪口は当て字。陶磁器の口径5cmぐらいの小さい酒杯を指すことが多い。写真は薩摩切子の猪口。江戸切子も人気だ。(鹿児島市)

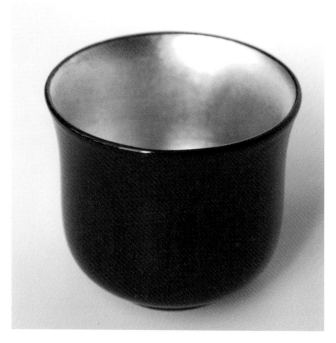

# *Guinomi* (Large Sake Cup)

A stocky drinking cup of slightly larger size than the *choko*. The *guinomi* is not only used for Japanese *sake*, but can also function as a shot glass when drinking whiskey. Because these cups are used in a carefree manner and can be arranged into sets, the number of *guinomi* collectors is increasing. The photograph shows a *guinomi* with gold leaf on lacquer. (Kyoto)

ぐい飲み

　猪口より寸胴でやや大ぶりの深い酒杯。日本酒ばかりでなく、ウィスキーなどを飲む際にショットグラス代りにも使える。気楽に使え、数を揃えられるため、コレクターも増えている。写真は金箔に摺り漆を施したぐい飲み。(京都市)

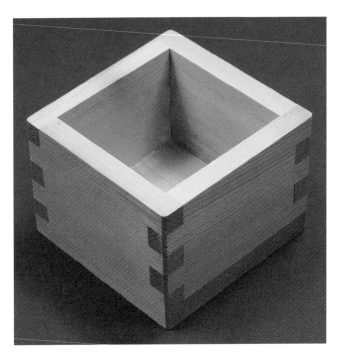

## *Masu* (Measuring Box)

A container used to measure out liquids or grains, made of wood or metal, and square or round in shape. The photograph shows a square *masu* for Japanese *sake*. The color, scent, and shaven texture of the wood can be savored. Drinking Japanese *sake* from a *masu* made with no effort spared is a special experience. (Kyoto)

桝

　液体や穀物などの分量をはかる器で、木製または金属製で方形や円筒形のものがある。写真は木の桝。木のもつ色、香り、削り上がりの雰囲気が味わえる。手間を惜しまず作られた桝で飲む日本酒は格別。(京都市)

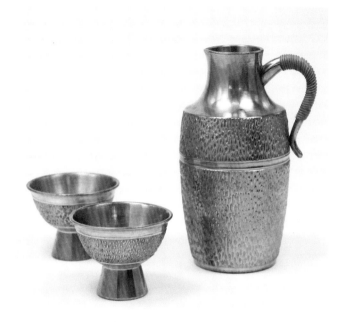

# *Shuki* (Sake Vessel)

These vessels are used to serve *sake*. The *shuki* shown in the photograph are made of pewter. If pewter vessels are used to serve hot *sake*, the *sake* can be warmed gradually, allowing the scent of the metal to seep into the *sake*, giving it a mellow flavor. The flavor reflects the extra effort involved, and cannot be obtained by simply heating *sake* in a microwave. It is thought that the things which make life enjoyable perhaps involve an extra investment of time and effort.

## 酒器

　　酒を酌むのに用いる器。写真は錫の酒器。錫の酒器で熱燗をすると、酒がゆっくり温まり、錫の香りが移り、円やかな味になる。「レンジでチン」では得られない、ひと手間かけた味だ。人生を楽しくするのは、手間と時間をかけたものかもしれない。

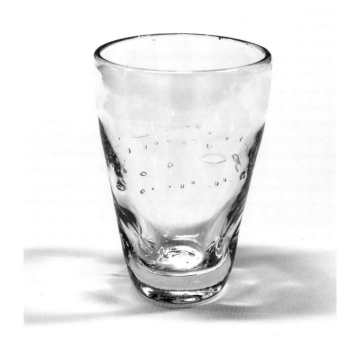

# *Koppu* (Glass)

The word *koppu* is derived from *kop*, the Dutch term for a cylindrical drinking glass. The photograph shows a glass tumbler made of Ryukyu glass from Okinawa, which had been reduced to burnt ruins in the Second World War. This glass, made of recycled glass bottles and other waste from drinks imbided by American soldiers, has a unique beauty. When the glass is held up to the light, one pictures the sea. (Naha, Okinawa prefecture)

コップ
　コップは円筒形の飲み物用の容器を指すオランダ語。写真は琉球ガラスのコップ。第二次世界大戦で焼け野原となった沖縄では、米兵が飲んだ飲料水などの廃瓶を再生して独特の美しさをもつガラスを作った。ガラスを光に透かすと海を感じる。(沖縄県那覇市)

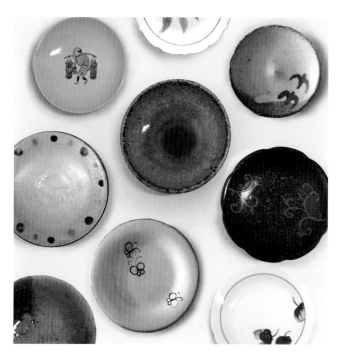

# *Mamezara* (Miniature Dish)

A small plate, approximately 8cm in diameter. When one arranges a variety of foods on various *mamezara* to enjoy over drinks with someone special, the plates will become a talking point for a lively conversation. The uses of the *mamezara* are entirely up to the user; they can hold colorful snacks for a party or can be used to hold one's jewelry. Lovely *mamezara* make life more fun.

豆皿

　直径8cmぐらいの小さな皿。多種のつまみを盛り大切な人と酒を酌み交すと、皿を話題にして会話も弾む。豆皿の用途は使い手の自由。色とりどりの菓子を入れてパーティをしたり、自分だけのアクセサリー入れにしたりもできる。素敵な豆皿は生活を楽しくする。

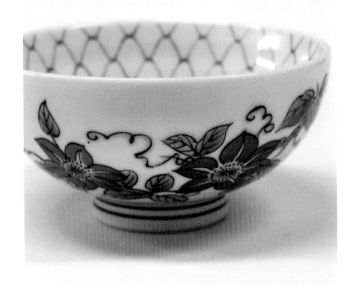

## *Meshi-wan* (Rice Bowl)

Rice is so important as a staple food in Japan that the phrase *gohan wo taberu* (eating rice) is used to refer to eating meals in general. The proper manners for eating rice in Japan are to hold the bowl in one hand while using chopsticks with the other. The bowl is lifted up close to the mouth when eating the rice. The photograph shows a *kutani meshi-wan* from Ishikawa prefecture, known as *iroejiki* (painted porcelain). (Nomi, Ishikawa prefecture)

### 飯碗

「ご飯を食べる」といえば、食事をとることも意味する。ご飯は日本人の大切な主食だ。飯碗を片手に、もう片方の手で箸を使って、口近くまで持ち上げて食べるのが日本のマナー。写真は色絵磁器で知られる石川県の九谷焼の飯碗。(石川県能美市)

# *Wan* (Soup Bowl)

*Negoro-nuri* is a lacquering technique in which a wooden dish is painted with an undercoat of black lacquer, followed by a top coat of vermilion. The wares created by this technique are also called *negoro-nuri*. The top coat of vermilion wears away after long periods of use, showing the black undercoating and giving the item an even more profound flavor. *Negoro* items with a black top coat are also prized. (Iwade, Wakayama prefecture)

## 椀

　木製の器に黒漆で下塗りをした上に、朱漆を塗る技法を根来塗と呼ぶが、この技法の器も根来塗という。長く使っていると上塗りの朱がはげて、下塗りの黒漆が現れて味わい深くなる。黒漆を上塗りした黒根来も珍重される。(和歌山県岩出市)

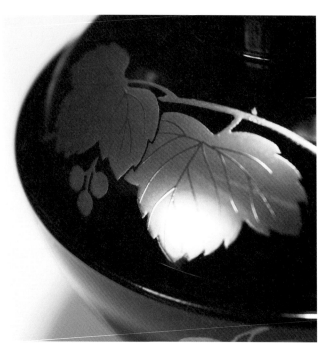

# *Futatsuki-wan* (Lidded Lacquer Bowl)

A *futatsuki-wan* allows the diner to look forward to lifting its lid and discovering what is inside. It is thought that the steam and scent which waft upward at that moment is a source of happiness. Lacquer bowls do not become hot to the touch even when they contain hot soup, and lids prevent the contents from cooling. (Kyoto)

**蓋付き椀**

　蓋付きの椀は、中に何が入っているかと蓋を開ける楽しみがある。立ち上る湯気と香りで幸せになる。漆器の椀は熱い吸物でも器が熱くなり過ぎず、蓋付きだと冷めにくい。(京都市)

## *Hachi* (Laquer Bowl)

Although there are many lacquer producing and exporting countries, lacquerware is a craft unique to the Far East. Lacquerware items were once known in English simply as "japan." Lacquer, which is a naturally occurring resin, has a beautiful sheen, is extremely durable, and has been used since ancient times. (Kyoto)

**鉢**
　漆器は漆産出国が多い東洋独特の工芸で、英語で漆器は「ジャパン」と呼ばれていた。天然樹脂の漆は美しい光沢をもち耐久性に優れ、古から塗料として用いられてきた。（京都市）

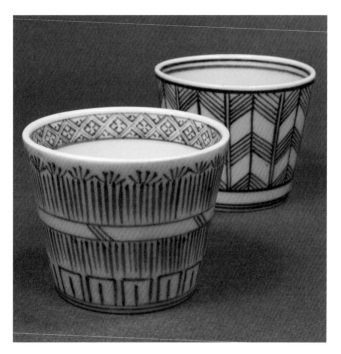

## *Sobachoko* (Soba Cup)

*Sobachoko* are cups used to hold the sauce that has been eaten with *soba* (buckwheat noodles) since the Edo period. Their diameter is usually around 7cm, with a height of between 4 and 6. The photograph shows a blue and white porcelain *sobachoko*. Because these are easy to handle and have a wide range of uses, they are popular among young people. (Kyoto)

### 蕎麦猪口

　蕎麦を食べる時につゆを入れる器で、江戸時代から存在する。口径は大体7cm前後が多く、底の径は4〜6cmほど。写真は染付磁器の蕎麦猪口。使い勝手が良く様々な用途に使えるため、若い人にも人気の器だ。（京都市）

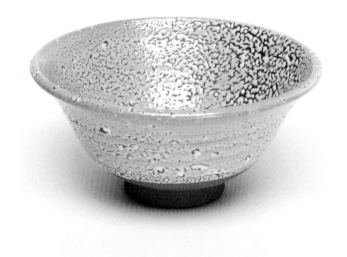

## *Chawan* (Tea Bowl)

This tea bowl has a milky white *choseki-yu* (p.123) applied to a loquat-colored body. The color of the clay can be seen through *haku-yu* (p.123). *Matcha* (powdered green tea) is thought to look its best in this tea bowl. Without the influence of Sen no Rikyu, the aesthetic sense of tea masters would most likely not have been honed to such a specific degree. (Hagi, Yamaguchi prefecture)

茶碗
　枇杷色の素地に乳白色の長石釉 (p.123) を施した茶碗。白釉 (p.123) から土の色が見え、互いを引き立て合う。緑の抹茶が見事に生かされる茶碗だ。千利休がいなければ、茶人の美意識はこれほどまでに研ぎ澄まされなかっただろう。(山口県萩市)

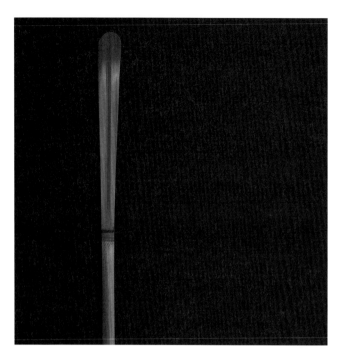

# *Chashaku* (Bamboo Tea Scoop)

Although a simple piece of equipment for the tea ceremony, this *matcha* tea scoop is held in particular regard. *Chashaku* are made of bamboo, which is not particularly expensive, yet, depending on the maker and his ancestry, they can be valued as works of art. Japan has not only marvelously skillful crafts, but also a culture of being moved by an artisan's personality. (Kyoto)

茶杓

　抹茶をすくい取るさじで、簡素な茶道具だが別格に尊重される。原料は竹なので材料費はさほど高くないはずなのに、作者や伝来によって手の届かない値がついている。日本には技の見事さだけでなく、作者の人となりに心を動かされる文化がある。（京都市）

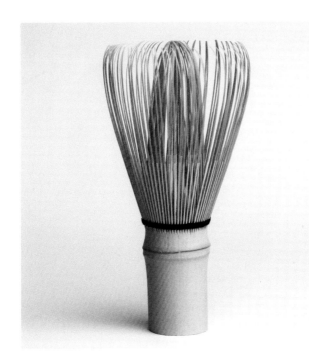

# *Chasen* (Bamboo Tea Whisk)

One of the pieces of equipment for the tea ceremony, used when making *matcha* tea. Although a new whisk is always provided and then disposed of at a tea ceremony, each is a work of art requiring fine skill. The form of a *chasen* differs according to the school of tea, and there are few master craftsmen who are able to carry out the entire process on their own. The number of blades can vary, but the greatness of the artisan's skill is apparent in the excellence of achieving 120 blades. (Kyoto)

## 茶筅

茶道具の1つで、抹茶を点てる時に使う。茶会では必ず新調され消耗されるが、繊細な技を必要とする工芸品だ。流派によって形も異なり、全工程を1人で熟す匠は数少ない。穂の数も様々だが120本の見事さに人の手技の凄さを見る。(京都市)

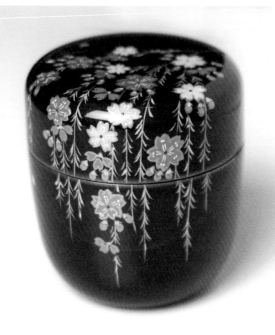

## *Natsume* (Container for Tea Powder)

This 6cm-tall container, which resembles the fruit of the jujube tree in shape, holds *matcha* for thin tea. Photographed is a tea caddy decorated with a *maki-e* (p.123) of weeping cherry blossoms in the moonlight, boasting both gold and lacquer decoration. When it is opened, petals seem to float through the air. Pieces made by Emperor Godaigo (1288-1339), using ivy at Yoshino mountain in Nara, are considered to be model tea utensils.

---

### 棗

　棗の実の形に似た高さ約6cmの容器で、おもに薄茶の抹茶が入れられる。写真は金に漆を重ね月にしだれ桜が描かれた蒔絵 (p.123) の棗。開けると花びらが舞うようだ。後醍醐天皇（1288〜1339）が奈良・吉野山の蔦を使って作ったものが茶器の原型とされる。

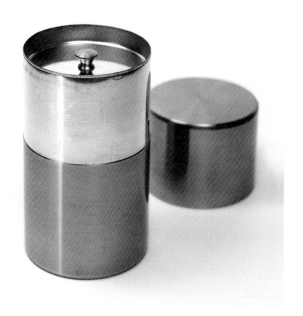

## *Chazutsu* (Container for Tea Leaves)

A vessel for storing tea leaves. Photographed is a copper *chazutsu*, whose lid slides slowly into place as if by magic. It is often difficult to believe these are made by hand, but such precise workmanship is typical of Japanese people. Craftworks that are "made in Japan" are flourishing. (Kaikado shop, Kyoto)

茶筒

　茶葉を保存するための容器。写真は銅製の茶筒で、蓋が魔法のようにスルスルとゆっくり落ちていく。外国の方には手作りだと言っても信じてもらえないかもしれないが、精密な手技は日本人ならでは。「メイド イン ジャパン」の工芸は健在だ。(京都市、開化堂)

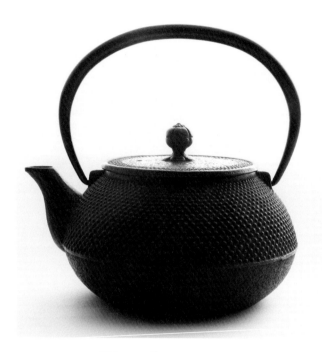

# *Tetsubin* (Iron Kettle)

An iron kettle placed over a portable brazier used to boil water in casual versions of the tea ceremony. It is also excellent for everyday use. Because hot water boiled in these pots becomes mellow and goes well with every kind of tea, the Japanese *tetsubin* is even popular overseas. Iwate, Yamagata, Osaka, and Shiga are known for their production of iron goods. (Iwate prefecture)

## 鉄瓶

　茶道の盆略点前などで、瓶掛や火鉢にかける鉄製の湯沸かし器。もちろん普段使いにも最適。沸した湯は円やかになり、どんな茶葉にも合うので、日本の鉄瓶は今や海外でも大人気だ。岩手や山形、大阪や滋賀も鉄器の産地として知られる。（岩手県）

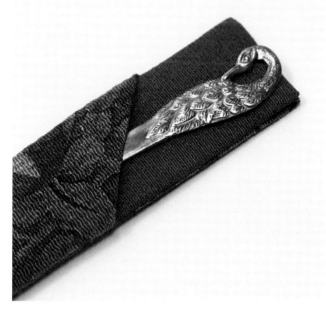

# *Kashikiri* (Japanese Sweets Knife)

*Kashikiri* is a utensil used when eating *wagashi* (Japanese sweets), and is an essential item when attending a tea ceremony. They can be made of spicebush wood, ivory, gold, bamboo, and other materials. Using *kaishi* (p.123) when given a confection and eating it with a *kashikiri* is thought to be a charming practice. The *kashikiri* in the photograph is *nanryo* (p.124) carved in the shape of a crane. (Kyoto)

## 菓子切り

　和菓子を頂く時に使い、茶席に入る時の必需品。素材は黒文字、象牙、金物、竹など多様。懐紙（p.123）にとって菓子切りで頂くと皿を傷めないのがゆかしい。写真は南鐐（p.124）で鶴が彫られている。美は細部に宿る。（京都市）

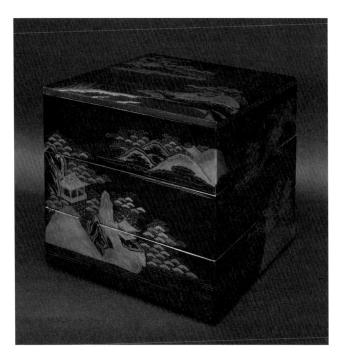

## *Jubako* (Tiered Boxes)

Box-shaped containers that are stacked in two, three, or five tiers for serving food. The boxes in the photograph are decorated with a *maki-e* of the Eight Views of Omi, a combination of the famous spots around Shiga and Lake Biwa, as well as elements from the Eight Views of Xiaoxiang, introduced from China. *Jubako* are filled with homemade food and enjoyed on family events.

### 重箱

　食物を盛る箱型の器で二重、三重、五重に積み重ねることができる。写真は近江八景が描かれた蒔絵の重箱。近江八景は滋賀・琵琶湖の名所と中国伝来の瀟湘八景の要素を組み合わせたもの。腕を振るった料理を重箱に詰めて、家族で行事を楽しむ。

## *Bento-bako* (Lunch Box)

*Bento* boxes have even become popular overseas recently. The photograph shows a *bento-bako* made of *tamenuri*, a type of lacquer for which vermilion or red iron oxide is used as a base coat. After the first coat has dried, it is rubbed with charcoal for a matte texture, and finished with a coat of clear or aventurine lacquer. This double layer of lacquer engenders a tone which has great depth to it. The surface becomes more transparent over time, creating an even more pleasant effect. (Nagano prefecture)

### 弁当箱

　最近は海外でも日本の弁当箱が流行しているという。写真は溜塗の弁当箱。溜塗は漆塗の一種で、下塗りに朱・ベンガラを用い、乾燥後木炭で磨いて艶消しを行ない、透漆や梨子地漆を塗って仕上げる。二層の重なりが奥行きのある色を醸し出す。歳月とともに透けてきて、一層良い感じになる。（長野県）

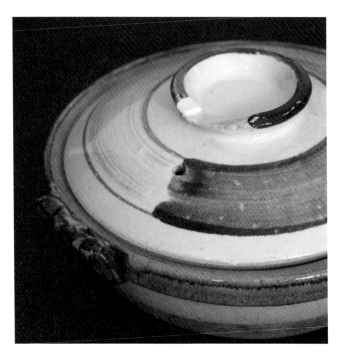

## *Donabe* (Earthenware Pot)

Due to its superior heat-retention, the *donabe* is invaluable for dining in the cold of winter. Japanese hot pot and meals, especially *gohan* (rice), cooked in the *donabe* are particularly delicious. Small, single-person sized *donabe* have also become popular recently. (Kyoto)

土鍋

　土製（陶器）の鍋は、保温性に優れ冷めにくいため、寒い冬場の食卓で重宝される。鍋料理はもちろん、土鍋で炊くご飯も格別に美味しい。最近は1人用の小さなサイズも人気だ。（京都市）

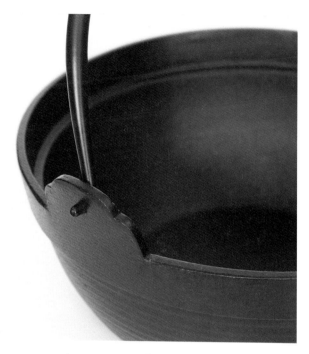

## *Tetsunabe* (Iron Pot)

Thick iron pots have excellent heat-retention properties and when the ingredients are stewed slowly, iron is said to dissolve into the mixture, allowing the diners to increase their intake of iron. On a winter's evening, simmering *daikon* radish and winter yellowtail produces a meal called *buri-daikon*, which warms you from the inside out. If the *tetsunabe* is used continuously on the hearth, it is thought to be even better than the *donabe*. (Kyoto)

### 鉄鍋

　厚手の鉄鍋は保温性に富み、食材をじっくり煮込むと鉄分が溶け込み鉄分補給もできるという。寒い夜、大根と寒鰤をコトコト煮て、鰤大根など食べると体も芯から温まる。囲炉裏にかけっ放しで使うなら、土鍋より鉄鍋がふさわしい。(京都市)

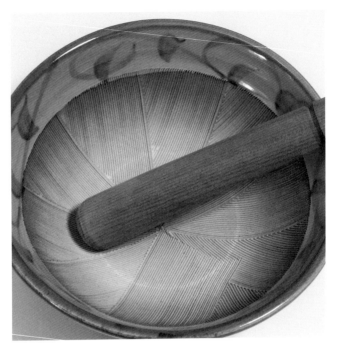

# *Suribachi* (Mortar)

A bowl used to mash, dissolve, and mix ingredients. A sharp eye is required of such detailed work. In the Showa period (20th century), *suribachi* were found in stores for household goods. Yanagi Muneyoshi (p.124) once said, "getting to know an area and its household goods stores often mean the same thing." (Kyoto)

---

**すり鉢**

　食材をすりつぶしたり、溶き混ぜるのに使う鉢。成型後に、すり目をたてる細かい手作業を要する。昭和の時代には、荒物屋に置かれていた。柳宗悦 (p.124) は「その土地を知ることと (そこの) 荒物屋を知ることは、しばしば同じ意味さえある」と述べたという。(京都市)

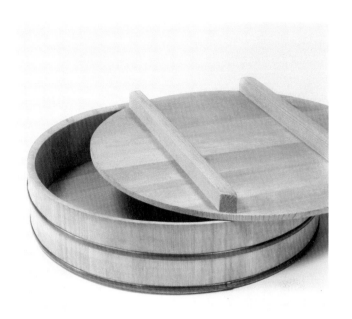

## *Hangiri* (Sushi Rice Bowl)

A wooden tub used for making *sushi* rice and serving *sushi*.
Cooked rice is transferred to the basin, seasoned with vinegar, and
stirred while it is cooled with an *uchiwa* fan. Because the *hangiri*
is made from wood, it absorbs just the right amount of moisture,
making delicious *sushi* rice. (Kyoto)

### 飯（半）切

　寿司飯を作ったり、寿司を盛りつけのに用いる桶。炊きたての飯を桶に移し、調味
料を調合した酢を全体に回しかけ、うちわであおぎながら混ぜ合わす。木でできてい
るから、水分を適度に吸って美味しい寿司飯となる。(京都市)

# *Shamoji* (Rice Spatula)

In the past, *shamoji* were primarily made of wood. The saying that a mother-in-law has passed the *shamoji* to her daughter-in-law meant that she had passed on the responsibility for the housework. *Boshu* (p.124), a day on the old twenty-four season calendar, is rice planting time, when the rain falls, the sun shines, and beautiful ears of rice grow. I want to serve the long-awaited new rice with a *shamoji* of fine, fragrant wood. (Kyoto)

## 杓文字

　ご飯をよそうもので、昔は木製が主だった。杓文字を姑が嫁に渡す時、家事を任せることを意味した。二十四節気の芒種(p.124)に田植えをして、雨が降り、陽が照り、秋にやっと稲穂が育つ。待ちに待った新米は良い木の香りの杓文字でよそいたい。（京都市）

# *Tofu-sukui* (Tofu Scoop)

A tool that is carefully woven to allow for delicate *tofu* to be easily scooped. *Tofu-sukui* fit smoothly into the hand and can be used for a long time. In this age of mass production and consumption, we are encouraged to buy replacements rather than mend the items we have, so it is fortunate that such items can be repaired. When we become attached to every-day things or find them particularly easy to use, it is hard to throw them away. (Kana-ami Tsuji shop, Kyoto)

豆腐すくい
　崩れやすい豆腐をすくいやすくするために、丁寧に手で編まれたものは、針金ので っぱりもなく手触りも滑らか。長く使っても修理をしてもらえるので有難い。大量生 産・大量消費の時代では、修理より新しく買い替えることを勧められる。しかし愛着 があったり、使いやすかったりすると、簡単に捨てたくはないのだ。(京都市、金網つじ)

Chapter 4

# Houseware

第四章

## 住

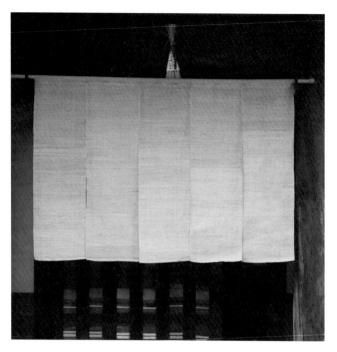

## *Noren* (Split Curtain)

Originally used as hanging curtains in Zen temples during the winter to prevent drafts. During the Edo period, *noren* were used in merchant households, dyed with the business name, and hung in front of the entrance. *Noren* offer privacy while allowing for airflow, and act as a sign to greet customers. (Kyoto)

**暖簾**

　もとは禅家で冬季の隙間風を防ぐのに用いた垂れ幕。江戸時代以降は商いをする家で、屋号などを染め抜いて軒先に下げるようになった。目隠しの役目を果たしながらも、風通しが良く、出迎えの看板代わりにもなっている。(京都市)

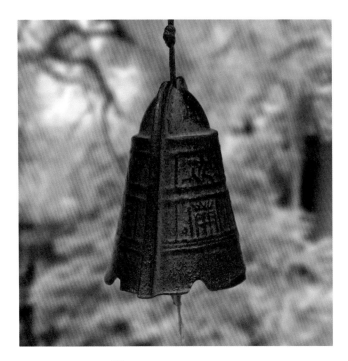

## *Furin* (Wind Chime)

Wind chimes made of metal or glass bells containing a strip of paper hung inside to catch the wind. Bronze, bell-shaped chimes hung at the corners of Buddhist temples and pagodas are called *futaku* (wind bells). *Haiku* poet Takahama Kyoshi (1874-1959) wrote a poem which reads, "I placed *furin* under the eaves, and the sound echoes..." This is a summer tradition which invites us to keep cool.

風鈴

　小さな鐘のような形で、中に風を受ける短冊などつけた金属やガラス製などの鈴。仏堂や塔の軒の四隅などに吊り下げてある青銅製の鐘形のものは風鐸と呼ぶ。俳人・高浜虚子 (1874〜1959) は「風鈴の音を點ぜし軒端かな」と詠んだ。涼へ誘う夏の風物詩。

## *Sudare* (Bamboo Blinds)

In Japan, the month of June also goes by the name of "the month of waiting for wind." In Kyoto, house fittings are changed around this time. *Fusuma* (p.125) and other components are put away and replaced with bamboo blinds or reed sliding doors to improve ventilation. *Sudare* are handmade by weaving finely split bamboo or reeds into rows with thread. The photograph shows elegant bamboo blinds from Kyoto. (kyoto)

簾
　6月の別名は風待月。京町家では建具替えが行なわれるころ。襖 (p.125) などを片付け、簾や葭戸にすると風が通り抜ける。簾は細く割った竹や葭を糸で編み列ねる手仕事。写真は雅な京簾。(京都市)

## *Shoji* (Sliding Screen)

The general name for fixtures placed on the inside of windows and frames as a partition. The photograph shows a round window that has Japanese paper attached on a *shoji* frame. In Zen teaching, it is thought that the *enso* (円相) calligraphy circle expresses spiritual enlightenment and truth. An *enso* (円窓) circular window is also used to mean a window which leads one's heart to the *enso* (円相). When you look through a circular window, what do you feel? (Kyoto)

### 障子

間仕切りとして、窓や縁の内側に立てる建具の総称。写真は、明かり障子に和紙を貼った丸窓だ。丸窓は円の窓で、円相に通じる。禅では円相は悟りや真理を象徴的に表したものとされ、円窓は己の心を映す窓という意味で用いられることもある。円窓を見てあなたはどんな気持ちになるだろうか。(京都市)

## *Byobu* (Folding Screens)

*Byobu* are house fittings used to prevent drafts and divide rooms. Pictures painted on their surface have come to be appreciated and admired. When unnecessary, these screens can be folded away. There are various sizes of *byobu*, ranging from small for bedside use, to several meters long. (Costume Museum, Kyoto)

屏風

　風よけや部屋の仕切りに用いられた調度品であったが、描かれた絵を鑑賞し愛でるものともなった。不要な時には折り畳むことも可能。枕元に用いる小さなものから数mにも及ぶものまで、サイズも様々ある。(京都市、風俗博物館)

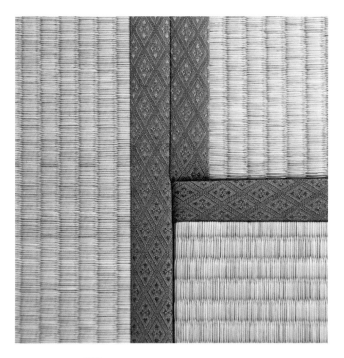

## *Tatami* (Woven Straw Mat)

The pleasant feeling of the *tatami* mat, which is well suited to Japan's hot and humid climate, is something I hope to pass on to the next generation. *Tatami* are made of *igusa* which are said to purify the air. It takes time and effort to make traditional *tatami*; grass must be cultivated from seed and grown for over a year before it can be harvested. It is then dried, woven, and fitted with a base and end-seams. I am grateful to artisans for their self-respect in preserving these traditional skills. (Kyoto)

## 畳

　　高温多湿の日本にあう畳の心地よさは、次の世代に伝えたいものの1つだ。い草には空気の浄化作用もあるという。い草は種子から栽培すると収穫までに1年以上の時間を費やすうえ、収穫後も乾燥、織、表張り付け、ヘリ付けなど、伝統的な畳を作るのは手間暇かかる。伝統の技を守ってきた職人の矜持に感謝。(京都市)

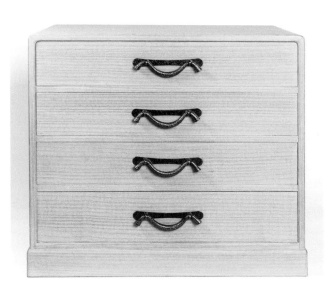

# *Kodansu* (Desktop Bureau)

A small bureau for storing documents and trinkets. Photographed is a *kodansu* which has been joined from various planks and rods without the use of nails. With an abundance of forests, woodworking in Japan was able to develop in its own way. Crafts and the global environment are like two sides of the same coin. The skill of joinery has continued since the Heian period, and has been underpinned by rich culture and natural surroundings.

## 小箪笥

　書類や小物を収納するための小さな箪笥のこと。写真は釘を使わず板と板、板と棒、棒と棒を組み、指し合わせた指物の小箪笥。日本の木工芸は豊かな森林を背景に独自の発達をなしえた。地球環境と工芸は表裏一体。平安時代から続く指物の技もまた、豊かな文化と自然に支えられている。

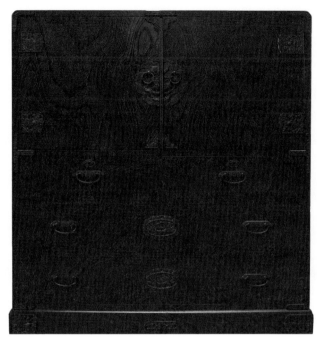

## *Jidai-dansu* (Antique Chest)

The beauty of the wood grain, lacquer surface, and metal fittings complement traditional Japanese *jidai-dansu*. In general, the term *jidai-dansu* indicates Japanese-style chests of drawers made between the mid-Edo and Taisho periods (18th-early 20th centuries), but there have recently been pieces made to match specific period designs. This design, in which we can sense the warmth of the natural materials, is typical of Japanese style.

### 時代箪笥

　木目の美しさや漆塗り、金具などが見どころで、三位一体となったものが価値も高い。おもに江戸時代中期から大正時代 (18〜20世紀前半) にかけて作られた和箪笥を指すが、最近は時代箪笥の意匠で、新しく作られるものもある。天然素材のぬくもりが感じられる和の意匠だ。

## *Tsuzura* (Wicker Basket)

The *tsuzura* is a lidded bamboo basket whose surface is made of Japanese paper coated with lacquer or persimmon tannin. This surface has antibacterial, insect repelling, and preservative properties, and is highly breathable. The subdued luster of the *tsuzura*, with its light and strong mesh, is beautiful. Precious *kimono* or tea ceremony items can be placed in this basket with peace of mind. Pictured is a *tsuzura* from Kyoto.

### 葛籠

　竹で編まれた蓋付きの籠。和紙の表面に塗られた漆や柿渋には抗菌、防虫、防腐作用があり、通気性にも富む。軽くて丈夫なうえに、渋い光沢のある網目が憎い。大切な着物や茶道具を入れても安心だ。写真は京葛籠。

# *Kobako* (Small Box)

A small box of wooden mosaic work, or *yosegi-zaiku*, which combines the natural coloring of various different types of tree to create geometric patterns. Wooden blocks are used to create patterns and arranged in a board shape to form the pattern block. A special plank is shaved into numerous paper-thin sheets which are then attached as decorative material. It is a small, environmentally friendly masterpiece for which not a single piece of wood has been wasted. (Hakone, Kanagawa prefecture)

## 小箱

　寄木細工の小箱。寄木細工は、様々な種類の木の自然な色合いを組み合わせ、幾何学文様を表す。木片を寄せて文様を作り、板状に集め種木を作った後、特殊な鉋で何枚もの薄い紙状の板に削り分け、その薄板を加飾材として貼り付けるのだ。小さな木片も無駄にしないエコの逸品。(神奈川県足柄群箱根町)

## *Hikite* (Door Handle)

*Kazari-kanagu* (p.125) are metal fittings used to decorate and strengthen buildings. Many of these metal ornaments were developed in the Momoyama period; door handles used for sliding doors also made astounding progress during this time. A great variety of materials and designs were developed to blend with the materials and colors used for buildings and fittings. The photograph shows a palace *hikite*, over 20cm in size. (Morimoto Decorative Metal Workshop, Kyoto)

### 引手

　錺金具 (p.125) の多くは桃山時代に発展し、それに伴い襖の引手もまた著しい進化を遂げた。引手は開閉のために手をかけるところだが、建物や建具の素材・色彩などにあわせ、素材や意匠も多様となる。写真は御殿引手と呼ばれる種類のもので20㎝を超える大きさ。（京都市、森本錺金具製作所）

## *Kugi-kakushi* (Nailhead Covers)

*Kugi-kakushi* are objects used to conceal the heads of large nails driven into the joints of horizontal beams and the pillars which they connect. In the *shippo* technique, the artisan piles colored, vitreous glazes into the metal fitting and fires it at a high temperature. Here, the ceiling is taken to be the sky, and vivid butterflies are let loose to fly around inside the room. (Morimoto Decorative Metal Workshop, Kyoto)

### 釘隠

　釘隠は柱と横向きに連結する長押とが交差する部分に打った、大きい釘の頭を隠すためのものだ。意匠は錺金具師が司る。七宝入り技法は、金具に七宝職人がガラス質の色釉薬を乗せ高温で焼成する。天井を空に見立て、鮮やかな蝶を室内に飛ばす。(京都市、森本錺金具製作所)

## *Kazari-ogi* (Decorative Fan)

*Kazari-ogi* are fans used for decoration. Painted on the fan in the photograph are pine trees, bamboo, plum trees, cranes, tortoises, wave-washed beaches, rocky coves, and Mount Horai (the Isle of Immortals floating in the sea). In Japan, it is customary to use celebratory objects and lucky patterns to decorate the surroundings at New Year. (by Hayashi Mikiko)

### 飾り扇

室内で飾るための扇子。写真の扇子には、松竹梅、鶴亀、州浜に荒磯、蓬莱山（海上にあり仙人が住む不老不死の楽園）が描かれている。日本ではお正月に縁起のいい絵柄、おめでたいものを飾る習慣がある。（林美木子／作）

## *Koro* (Incense Burner)

This silverwork cover, minutely carved by hand, is for a celadon incense burner. Many Japanese arts and crafts depict nature so that when, due to illness or other circumstances, one is unable to go outside, one can still enjoy the seasons. Looking at the object while remaining inside, one can travel to a beautiful natural setting in their mind's eye and find healing there.

香炉

　青磁の香炉に緻密な手彫り銀細工の火屋。日本の工芸品には自然がよく描かれている。病気や事情があって出かけられない時でも、室内で工芸品を見ることで、四季を楽しみ、自然の美しい場所へ心の翼で飛んで魂を癒せるよう、心を込めて作られているからだ。

## *Nioi-bukuro* (Fragrance Bag)

Sachets which hold a blend of chopped aromatic materials such as cloves, musk, or sandalwood. There are both portable sachets and bags for use inside of a room. You can enjoy your favorite scent by slipping it inside the sleeve of a *kimono* or placing it in a chest of drawers. The photograph shows an incredibly unique incense sachet in the shape of a persimmon, which makes the viewer think of fall. (Kyoto)

匂い袋
　丁子・麝香・白檀などの香料を刻んで調合したものを入れる袋で携帯用・室内用がある。お気に入りの香りを着物の袂に忍ばせたり、簞笥に入れたりして楽しむ。写真は季節感ある柿の形の個性的な匂い袋。(京都市)

104

## *Inko* (Pressed Incense)

The culture of incense is said to have begun with the mixing of *takimono* (p.125), with which residants of the Imperial Palace amused themselves in the Heian period. They gathered the sweetest-smelling woods, varied their proportions, and created fragrances to their own taste. *Inko* blocks are made by kneading various naturally-occurring fragrances together, pouring the paste into a mold, leaving it to harden, cutting it to shape with a stamp, and drying it. (Yamadamatsu Incense-wood Co., Ltd., Kyoto)

### 印香

香りの文化は、平安時代に宮人たちが興じた薫物 (p.125) に始まるといわれる。極上の香材を揃え、割合を変え自分好みの香りを創作していた。印香は様々な天然香料を練り合わせ、型に入れて固め、型抜きして乾燥させたもの。(京都市、山田松香木店)

## *Kaki* (Flower Vase)

Bamboo crafts in Kyoto broke free from continental influences and, along with the rise of the tea ceremony, developed a distinctively Japanese artistic style. One of these sophisticated crafts is a bamboo basket with a water vase attached inside. There are also pieces which retain the natural surface of the bamboo, as well as pieces like those in the photograph, which make use of lacquer for an extraordinarily delicate texture.

### 花器

　京都の竹工芸は、茶の湯の盛行とともに大陸からの影響を脱し日本的な独特の作風も発展させてきた。竹籠の中に水入れ器の付いた高度な細工ものもある。仕上げは素材のままのほか、写真のように漆塗りを施し、繊細で見事な風合いのものもある。

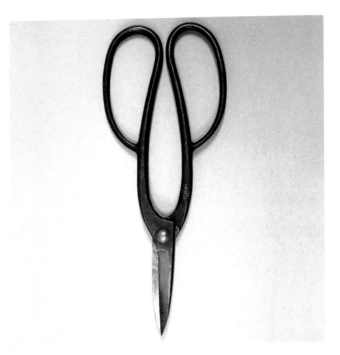

# *Ueki-basami* (Shears)

Garden scissors which both fit into the hand and cut well are a pleasure to use. In Japan, it is said that, "scissors cut with the reverse of the blade," and that the quality of the reverse side of a pair of scissors is what determines how sharp they are. Polishing the reverse of the blades by hand, one at a time, is the essence of the craftsman's skill. When the weather is rainy, plants grow fast and scissors help to keep the greenery in the garden beautiful. (Kyoto)

### 植木ばさみ

　植木ばさみは手になじみ、切れ味の良いものが小気味よい。「はさみは裏で切る」といわれ、はさみの裏側の良し悪しではさみの切れ味が変わる。手作業で1本1本行なわれる裏研ぎは、職人の技の粋だ。雨の季節は草木の成長が早い。庭の緑の美しさは、はさみにも支えられている。（京都市）

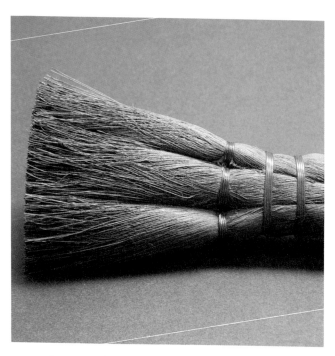

## *Shuro-bouki* (Small Hemp-palm Broom)

*Shuro* is the generic name for trees of the Palmae family in Japanese. The timber of these trees is used for pillars and trays, the fibers for ropes and brooms, and the fronds, bleached and used for summer hats or floor coverings. Artisans from various industries are involved in making sure that every single part of the palm is put to use. All living things are connected, in some way, to crafts. (Wakayama)

### 棕櫚箒

　ヤシ科シュロ属の常緑高木の総称を棕櫚という。材は柱や盆に使い、繊維は縄や箒とし、葉は晒して夏帽子や敷物にする。棕櫚は様々な業種の職人がかかわり、余すところなく使われる。地球の生きとし生ける物は工芸と繋がっている。(和歌山市)

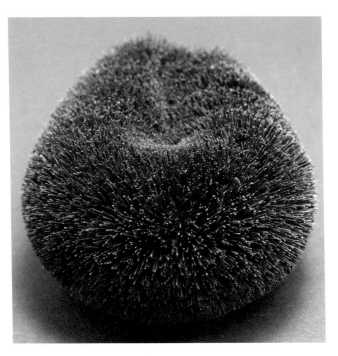

## *Tawashi* (Scrubbing Brush)

*Tawashi* are tools made by bundling rice straw or hemp-palm fibers that are used to wash things. The characters used to write its name literally mean, "something bundled," which expresses its meaning brilliantly. Recently, scrubbing brushes made of nylon can also be found, but the photograph shows a *tawashi* that has been handmade from natural materials. It is both sturdy and environmentally friendly. A kitchen which has been scrubbed until it sparkles is refreshing. (Wakayama)

### 束子
　藁、棕櫚の毛などを束ねて作り、物を洗うのに使う道具。漢字は意味を見事に表す。最近はナイロン製も見かけるが、写真は天然素材で手作りの束子。丈夫で環境にも優しい。ゴシゴシ擦ってピカピカになった台所は清々しい。(和歌山市)

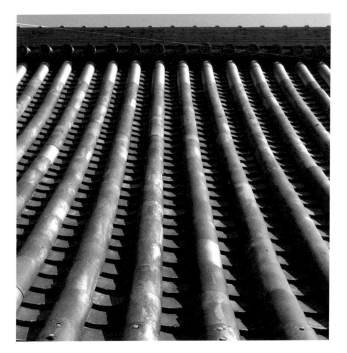

## *Yane-gawara* (Roof Tiles)

When we look up at roof tiles, their straight lines create a pleasant sensation. Handmade tiles differ ever so slightly in shape, so they must be carefully arranged in straight lines to match the form of the roof. They are also beveled so that three-tenths of the surface is visible and seven-tenths is hidden. The finished result is exceptionally beautiful. (Kyoto)

### 屋根瓦

　屋根瓦を見上げると真直ぐに並んでいて気持ち良い。手作りの瓦は微妙に形が異なり、葺く時に場所にあわせ真直ぐになるよう組み合わせて並べられる。瓦の面取りも見える方を三分、見えない方を七分とる。仕上げは格別に美しいのだ。(京都市)

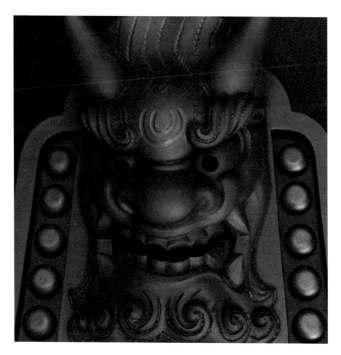

# *Oni-gawara* (Decorative Ridge Tile)

A type of decorative tile placed on the end of the ridge of a roof in order to ward off evil spirits and other dangers. The artisans who make *oni-gawara* are called *onishi*. Although Sanshu-gawara (Aichi prefecture), Sekishu-gawara (Shimane prefecture), and Awaji-gawara (Hyogo prefecture) are famous for this craft, craftsmen have dwindled in numbers. These highly polished, handmade *oni-gawara* may have scary faces, but somehow seem friendly and dependable. (Asada Kawara Factory, Kyoto)

## 鬼瓦

　屋根の棟の端に置く飾り瓦の一種で、魔除けや厄除けとして置かれる。鬼瓦を作る職人を鬼師という。三州瓦（愛知県）、石州瓦（島根県）、淡路瓦（兵庫県）が有名だが、鬼師は少なくなってしまった。磨きこまれた手作りの鬼瓦は怖い顔なのに、どこか優しく頼もしい。（京都市、浅田製瓦工場）

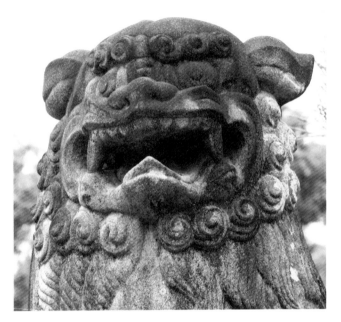

## *Koma-inu* (Guardian Lion-Dogs)

These lion-dogs are placed at either the entrance to a shrine, or on both sides of the main sanctuary, in order to ward off evil spirits. These are legendary creatures whose roots harken back to the lions who acted as the guardians of the gods in ancient India. *Koma-inu* stand as a pair, one facing forward with its mouth open, and the other with its head to the side and mouth closed. They stand to represent the beginning and end of all things. (Kyoto)

狛犬

　魔除けのため神社の入口や本殿の両脇に置かれる。想像上の動物で、起源は古代インドの守護獣であった獅子という。左右で一対、一方は角がなく口をあけた阿形、もう一方は頭に角があり口を閉じた吽形。阿吽は万物の初めと終わりの象徴。（京都市）

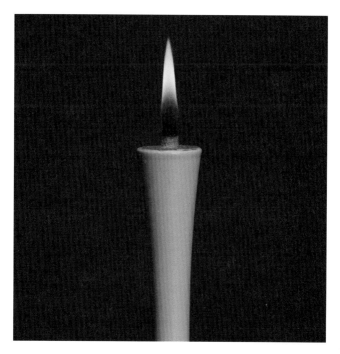

## *Warosoku* (Japanese Candle)

The *warosoku* is often made using fruit picked from the *haze* tree. The wax of the *haze* tree has a particular viscosity that burns with a beautiful flame. Because the spongiform pith of a reed wrapped in Japanese paper is used for its wick, the Japanese candle is made of completely natural materials. (Kyoto)

和ろうそく
　和ろうそくはハゼの木から採取した実を原料とするものが多い。ハゼの実から採れるろうは、独特の粘りがあり、火を灯した時に美しい炎となる。芯もスポンジ状のい草の髄を和紙に巻いたものを用いるので、材料は全て自然素材。(京都市)

# Conclusion

## The Spirit of Craftwork

In Japan, there is a traditional occupation called *kazarishi,* or decorative metal worker. The title describes a professional who handmakes various types of decorative metals, such as *hikite* and *kugi-kakushi* (see p.100~101), ceremonial objects, and metal fittings for Buddhist temples and Shinto shrines. Once you are aware of this craft, you will begin to notice the finest details of Japanese architecture.

Morimoto Yasunosuke, a third generation *kazarishi*, once told me, "my father taught me that when an artisan puts his body and soul into his work, it is an expression of religious faith. The most fundamental element of craftwork is the spirit, which allows us to have pride and human dignity." Although Mr. Morimoto passed away 10 years ago, I often remember my time with him, especially his smile and laughter when discussing technology and the idea of creating Buddhist statues with a 3D printer.

おわりに

●もの作りの「心」

「錺師」という仕事がある。第四章で紹介した襖の引手や釘隠 (p.100～101) といった小さな細工から仏具、祭具、神社仏閣の建築金具まで、様々な種類の錺金具を手作業で作り上げている職人だ。錺師の技を知ると、日本建築の細部にまで興味をもてるようになる。

錺師のひとり、三代目森本安之助は「その仕事に全身全霊を打ち込むことが、神仏に対する我々職人の信仰心の表れであると父は教えてくれました。手作りの基本は心です。それが人間の尊厳を誇れるゆえんでありましょう」と語った。10年ほど前に彼は天国に旅立たれたが、私は彼の言葉とその清々しい笑顔が忘れられない。とり

Today, Morimoto Yasunosuke IV is continuing the *kazarishi* tradition.  When I spoke with him, he told me, "Kami (the Gods) are watching, so I know that cutting corners is out of the question." His statement made me completely understand the presence of a craftsman spirit that had been passed from father to son. However, we are entering an age in which the work of a master *kazarishi* can be done with a 3D printing machine.

On your next visit to a Buddhist temple or Shinto shrine, after you raise your hands in prayer, please give thanks to the lives of all the craftsman who have contributed to the beauty and splendor of the handmade objects in the altar and ask yourself: can the spirit of the craftsman be printed by a machine?

Sawada Mieko

わけ、3Dプリンターの仏像のアイデアについて話した時、大笑いされたことを思い出す。

彼の息子もまた四代目森本安之助として、錺師の仕事を受け継いでいる。「神様は24時間、365日見ておられる。そやからごまかしはきかへん」と口癖のように言う。私はここに父から息子へと職人魂がしっかり受け継がれているのを目の当たりにした。しかしながら、錺師の仕事も3Dプリンターで作れる時代を迎えた。

読者のみなさんにも、お寺や神社にお参りに行った時、ぜひ錺金具を見ていただきたい。そして、もしその技の見事さに心打たれたら、どうか錺師が真摯に心を込めて仕事をしている姿を想像してほしい。はたして、あなたは3Dプリンターが作ったものでも同じ感動を得ることができるだろうか。　　　　　　　　　澤田美恵子

Appendix

# Glossary

付録

用語集

# Glossary | 用語集

## *Hariko*

Paper that is moistened with water, pasted on a wooden form with glue, and pounded with a wooden mallet when dry.

## *Rokuro*

A lathe mechanism used for pottery and woodworking. When used for woodworking, it is able to create rounded forms. When used for pottery, clay is placed on top of the wheel, which creates various rounded shapes while turning.

## *Gofun*

Made of scallop shell, the main element of which is calcium carbonate. Not only is *gofun* used as a white medium for Japanese paintings, dolls, and *kimono*, but it is also used for woodwork decoration.

第一章

### 張り子 はりこ

紙を水につけて濡らしたものを、木型に重ねて糊で貼り、木槌などでたたいて形を整えた後、乾燥させて木型から外したもの。

### ろくろ

木工や陶芸に使われる器械。木工に使われるものは旋盤で回転形を作ることができる。陶芸に使われるものは円盤に陶土をのせて回転させながら円形の様々なものを作ることができる。

### 胡粉 ごふん

原料は貝殻で、主成分は炭酸カルシウム。白い絵具として、日本画や、人形、着物のみならず、木工品の装飾などにも使用される。

## Tango no Sekku

Successive, odd-numbered days such as 1/1, 3/3, 5/5,7/7 and 9/9 are called *sekku* (seasonal festival). The 5th of May is Tango no Sekku, for which carp streamers are hung and *gogatsu-ningyo* decorated to celebrate the healthy development of young boys. After the Second World War, this day became the public holiday Kodomo no Hi (Children's Day).

## Momo no Sekku

One of the *sekku*, for which the *hina-matsuri* (Doll's Festival) is held on the 3rd of March. For this event, dolls are decorated and sweet white *sake*, *mochi*, and peach blossoms are offered to pray for the growth and happiness of young girls.

## Jyuni Hitoe

Common name for women's imperial court clothing in the Heian period. Red *hakama* pants are worn over a white, under-*kimono* and many robes are layered on top. The complex gradation of the colors showing at the front of the collar is called *nioi*.

**端午の節句**
たんごのせっく

1月1日、3月3日、5月5日、7月7日、9月9日など奇数が重なる日は、節句と呼ばれる。5月5日は端午の節句といい、鯉のぼりや五月人形を飾り、男の子の健やかな成長を祝う。第2次世界大戦以後は「こどもの日」として国民の祝日となっている。

**桃の節句** もものせっく

節句の1つで、3月3日に女の子の成長や幸せを祈る雛祭りが行なわれる。雛祭りは雛人形をかざり、白酒（甘酒）や菱餅、桃の花などを供える。

**十二単** じゅうにひとえ

平安時代、朝廷に仕える女官の服装の俗称。白小袖の上に紅の袴をはき、何枚もの衣を重ねて着る服装。その襟元に表れる重ねた同色の濃淡のグラデーションを「におい」という。

## Habutae

*Habutae*, a representative silk good, is a fine-quality white textile. Raw silk threads are finely woven to create a lustrous fabric that is agreeable to the touch.

## Oisho

One of the various types of Japanese embroidery needles. Because there are different needles depending on the technique and fabric used for the embroidery, the thickness and shape of these needles range from *gokuboso* (super fine) to *obuto* (very thick). The *oisho* is often used on such crafts as silk gauze *kimono* and costumes for the Noh theater.

## 羽二重 はぶたえ

羽二重は、絹織物の代表的で上質な白生地。生糸を使って織った緻密で光沢がある肌触りの良い布である。

## 大衣裳 おおいしょう

日本刺繍の針の名前の1つである。刺繍針は技法や生地によって使う針が違うため、針の太さや形により、「極細」から「大太」まで何種類もある。大衣裳は、特に絽の着物や能装束に用いることの多い針。

## Chapter 2

### *Kyonui*

Since its time as capitol city in the Heian period, Kyoto has been home to specialized craftsmen who command the realm of embroidery. The traditional techniques of these craftsmen have been passed down as *kyonui*. There are still approximately 30 sophisticated techniques employed in decorating fabrics today.

### *Kinuya Saheiji* (1683-1744)

Kinuya Saheiji is regarded as the father of *tango-chirimen*. His name was later changed to Morita Jirobe, and a stone monument in his honor still reads "birthplace of the venerable Morita Jirobe, founder of Tango *chirimen*."

### *Kushioshi Nassen*

Dyes are placed on a wooden block that is bowed like the back of a comb. This is a technique which follows the already completed pattern and dyes the thread before it is woven.

第二章

**京繍** きょうぬい

京都は平安京の時代から刺繍を司る専門の職人がおり、伝統的な技法を受け継いできた。その刺繍を京繍という。現在も約30種類の技法があり、高度な技法で布地に加飾している。

**絹屋佐平治**
きぬやさへいじ
（1683 〜 1744）

絹屋佐平治は丹後縮緬の祖と仰がれる人物。後に森田治郎兵衛と改名したが、「丹後ちりめん始祖森田治郎兵衛翁発祥地」の碑が遺っている。

**櫛押捺染**
くしおしなっせん

図案通りに糸に墨付けし、櫛に似た木片に染料をつけ、先に墨付けした印と印の間を染める。

## *Katagami Nassen*

After thread is wound around the edge of a standard-width *kimono* frame, a piece of paper that has been cut into a pattern is placed on top and dyed.

## *Hitoe*

Japanese clothing that has been tailored without lining. This type of *kimono* is typically worn between the months of June and September.

## *Igusa*

Although *igusa* grows as a perennial plant in wetlands and marshes, it can also be cultivated in rice fields. Its cylindrical stalks grow to a height of around 1 meter. The white piths are used as candle wicks, and its stalks, for crafts such as *tatami* and *zori*.

## 型紙捺染
### かたがみなっせん

着尺幅の枠に糸を巻き、柄彫りした型紙を使って、糸を染めていく技法。

## 単衣 ひとえ

裏をつけないで仕立てた和服。おもに6月と9月に着られる。

## い草 いぐさ

多年草で、湿地に自生するが、水田で栽培することもできる。高さ1m、茎は円柱形。茎は畳や草履、白い髄はろうそくの灯心に用いられる。

## *Choseki-yu*

A glaze made of feldspar minerals. Because glaze is applied to the surface of unglazed ceramics, the wares will not absorb water and will be decorated with a glassy finish.

## *Haku-yu*

White overglaze, prized for its soft white color.

## *Maki-e*

A lacquering technique in which powdered pigments and metals made from gold, silver, copper, and tin are adhered to designs drawn with *urushi* (lacquer).

## *Kaishi*

A piece of once-folded *washi* (Japanese paper) that is small enough to be kept in the chest of a *kimono*, close to the heart. Not only are these papers used when eating sweets during a tea ceremony, but also for wrapping, carrying objects, and wiping, and can also be used for writing memos.

第三章

**長石釉** ちょうせきゆう

長石を原料とした釉薬の1つ。釉薬とは素焼きの陶磁器の表面にかけて、水分が素地に染みないようにするもので、ガラス質のため装飾にもなる。

**白釉** はくゆう

白い釉薬。柔らかい白色が特徴。

**蒔絵** まきえ

漆の技法の1つで、漆で文様を描き、金、銀、銅、錫などの金属の粉や色の粉を蒔きつけて、付着させる技法。

**懐紙** かいし

着物の懐に入る大きさの2つに折りたたんだ和紙。茶道でお菓子を食べる時のみならず、携帯していると包んだり、拭いたり、何かのメモを書くことにも使える。

## Nanryo

Beautiful, fine-quality silver that has been refined.

## Yanagi Muneyoshi (1889-1961)

A Japanese philosopher born in Tokyo. Yanagi developed a folk-crafts movement in which he termed common crafts—everyday objects which hadn't, prior to 1925, been seen as objects of beauty—*Mingei*.

## Boshu

A calendar which delineates the twenty-four seasons of the year, according to the movement of the sun on the ecliptic plane, is used for agriculture. *Boshu*, as a day of the twenty-four seasons, falls on June 6th, and is the standard time for sowing crops such as rice and barley.

## 南鐐 なんりょう

精錬した美しい上質の銀。

## 柳宗悦 やなぎむねよし
（1889 〜 1961）

日本の思想家で、東京に生まれる。1925年ごろからそれまで美の対象とされてこなかった民間で用いられる日常品、民衆的工芸品を「民藝」と呼び、民藝運動を展開した。

## 芒種 ぼうしゅ

1年の太陽の黄道上の動きを24等分して決められている「二十四節気」は、農業にも使われる。芒種は二十四節気の1つで、6月6日ごろにあたる。稲や麦などの種をまく目安の時期である。

## *Fusuma*

A house fitting made by affixing materials such as paper and cloth to either side of a wooden frame.

## *Kazari-kanagu*

Metallic components and wares used to both stabilize Japan's traditional architecture, including Shinto shrines and Buddhist temples, and create beautiful designs. Similar crafts include the *hikite* (doorknob) and *kugi-kakushi* (nailhead cover).

## *Takimono*

Another name for incense of various blended scents. The act of burning incense to permeate a room or *kimono* with fragrance is also called *takimono*.

## 襖 ふすま

骨組を木で作り、両面に紙や布を張った建具のこと。

## 錺金具 かざりかなぐ

金属性の部品や細工物で、神社仏閣をはじめとする日本の伝統建築を強固にし、意匠として美しくするもの。身近なところでは、引手や釘隠、等がある。

## 薫物 たきのもの

各種の香を練りあわせて作った練香そのものの呼び名でもあり、またその香を焚いて着物や部屋などに香りを移せることも薫物という。

**澤田美恵子**　さわだ・みえこ
京都工芸繊維大学教授。博士 (言語文化学)。
工芸評論家 (https://lovekogei.com)。
京都市生まれ。大阪外国語大学大学院修了後、
グルノーブル大学 (フランス) 講師、神戸大学助教授、
京都工芸繊維大学准教授を経て現職。
著書に『現代日本語における「とりたて助詞」の研究』
(くろしお出版)、『やきもの そして 生きること』(理論社)、
共著に『京の工芸ものがたり』(理論社)
『工芸の四季』(京都新聞出版センター) など多数。

**中野仁人**　なかの・よしと
京都工芸繊維大学教授。博士 (学術)。
京都市生まれ。専門はグラフィックデザイン。
京都コンサートホールや京都国立博物館の
シンボルマーク、京都・錦市場をはじめ
様々な場所の視覚統一デザインを手がける。
共著に『紙—昨日・今日・明日』(思文閣出版)、
『京の工芸ものがたり』(理論社)、
『工芸の四季』(京都新聞出版センター) などがある。

編集協力
齊藤尚美 (くるみ企画室)

装丁・本文デザイン
金田一亜弥　髙畠なつみ (金田一デザイン)

用語集英訳・英文校正
Devon Menuez

校正
小学館出版クォリティーセンター

本書は『工芸の四季—愛しいものがある生活』
(2013 年京都新聞出版センター刊) を
一部再編集し、英語訳を付けたものです。

Bilingual Guide to Japan
JAPANESE CRAFTSMANSHIP

# 工芸バイリンガルガイド

2018年12月11日　初版　第1刷発行

著　者　澤田美恵子　中野仁人
発行者　斎藤　満

発行所　株式会社小学館
　　　　〒101－8001
　　　　東京都千代田区一ツ橋2－3－1
　　　　編集　03－3230－5563
　　　　販売　03－5281－3555
　　　　編集／矢野文子　販売／鈴木敦子

印刷所　大日本印刷株式会社
製本所　株式会社若林製本工場